THE NINE GIFTS

OF THE HOLY SPIRIT

BELONG TO YOU!

MEL BOND

Unless otherwise indicated, all Scripture quotations are taken from the King James Version of the Holy Bible.

All Greek and Hebrew definitions are taken from the New Strong's Expanded Exhaustive Concordance of the Bible, published by Thomas Nelson (2010).

Note: When the letter G (for Greek) or H (for Hebrew) is within parentheses, this indicates words that are synonymous to the word that is rendered in the King James Version and the fuller meaning of such word or phrase in the Greek or Hebrew. For example, in Matthew 7:7, the word "Seek" means (G = to plot against life: desire, enquire, to question), "and ye shall find;".

The author has emphasized some words in Scripture quotations in italics. These words are not emphasized in the original Bible version.

Carol A. Perolio, Editor

THE NINE GIFTS OF THE HOLY SPIRIT BELONG TO YOU!
ISBN: 978-1-882318-03-2
Copyright © 2016, Mel Bond
P.O. Box 306
140 North Point Prairie Road
Wentzville, Missouri 63385

Published by: Mel Bond
Agape Church
P.O. Box 306
140 North Point Prairie Road
Wentzville, Missouri 63385

Printed in the United States of America.

Contents

1

GOD DESIRES TO USE YOU

Did you know that God desires to use you? Did you know that God's greatest blessings are right in front of you? We are going to be talking about the mystery of the ages and how it is here *now*. I am going to establish the fact that God has already given to each one of us all the gifts of the Holy Spirit. Our job, as believers, is to understand how they operate and to flow with each of the gifts He has given us. Then I will teach you in detail about the nine gifts of the Holy Spirit and show you from the Scriptures how each gift has an office.

The Bible makes it clear that God has already given to us all things that pertain to life and Godliness. (2 Peter 1:3) The nine gifts of the Holy Spirit pertain to life and Godliness and have therefore been given to us. Also, everything God does is simple. If it is not simple, God is not in it. Psalm 119:130 says it this way: "The entrance of thy words giveth light; it giveth understanding unto the simple." With these two basic truths then, let me just add that there are a whole lot of things that God cannot do unless He does them through us.

God is wanting to flow through a people with a last days' anointing and with all of the gifts of the

1

Holy Spirit. He is looking for vessels that He can flow through. He could have designed it another way but He didn't. In essence, God needs you. 2 Corinthians 1:20 states: "For all the promises of God in him are yea, and in him Amen, unto the glory of God *by us*." The word "glory" in that verse is the Greek word "doxa". The fuller meaning of that word is "reputation of God". God needs *us*, in other words, for His reputation to flow through. And again, "Now thanks be unto God, which always causeth *us* to triumph in Christ, and maketh manifest the savour of his knowledge *by us* in every place." (2 Corinthians 2:14) *It is by us!*

In Colossians 1:26-27, we read: "Even the mystery which hath been hid from ages and from generations, but now is made manifest to his saints: To whom God would make known what is the riches of the glory of this mystery among the Gentiles; which is Christ in *you*, the hope of glory:". The word "mystery" that we just read is co-equally rendered in the Greek as "God's deep secret". It is a secret that has been hid for ages but is now made manifest to *us*. Christ in *you* is the hope of God being glorified.

Long ago, God had hope that He would be well glorified through Jesus. And He was not disappointed. Jesus did a good job. He well glorified God. In fact, He was the perfect example of the reputation of God on the earth. Again, the word "glory" and "glorified" are the same Greek word that means the "reputation of God". No matter what they did to Jesus, He glorified the Father. They could not even kill Him until He laid His life down and submitted to death.

2

I thank God for Mel Gibson and I pray that Mel Gibson reads this book. Mel, I want you to know that God loves you very much and He thanks you so much for putting that movie out, *The Passion Of The Christ*. God also wants you to know that He doesn't hold anything against you. God not only loves you very much but you are valuable and precious to Him. However, long before Mel Gibson produced that movie, I saw clearly in the original language of the Bible, that Jesus was absolutely slaughtered to the point that He was unrecognizable as a human being when they finished beating and torturing Him. We read in Isaiah 52:14: "...his visage [face] was so marred more than any man, and his form more than the sons of men:". But they could not kill Him until He finally said Father it is finished, the price has been paid and now I will die. The Roman soldiers were amazed and absolutely astonished at how a person could still be alive after the torture and the slaughter He endured. They bowed their knees and said surely He was the Son of God.

God now says in His Word, I have so much hope in *you*, that you will represent me the way that Jesus did. That is the only reason that God let Him die. God had, and still has, that much hope that you would represent God as much as Jesus did and even more. "Verily, verily, I say unto you, He that believeth on me, the works that I do shall he do also; and greater works than these shall he do; because I go unto my Father. And whatsoever ye shall ask in my name, that will I do, that the Father may be glorified in the Son. If ye shall ask any thing in my name, I will do it." (John 14:12-14)

God says that the works that Jesus did you shall do also and even greater works than these shall you do. God has more hope in us than we do! You need to stop believing your brain and what other people think or say about you and just start believing what God says. God is smarter than we are. If God said it, we just need to believe it.

Forget about your reputation. Forget about your past and present and everything you have ever done wrong. It is not based on your goodness. It is based on the goodness of God. You can't earn what He has for you and you can never get good enough to receive all that He has for you. Jesus already paid the price and it is yours. It has been given to us by the grace of God. Because of the price that Jesus paid, we have the gift of being in right standing with God. When God looks at you, He sees you through the blood of Jesus being slaughtered. Jesus paid the price for you to be the perfect reputation of God. He sees you as perfect.

And if God says you are perfect, I wouldn't disagree with Him. He's big! God is a BIG GOD. Isaiah 40:12 confirms that God is BIG: "Who hath measured the waters in the hollow of his hand, and meted out heaven with the span, and comprehended the dust of the earth in a measure, and weighed the mountains in scales, and the hills in a balance?" God is a BIG GOD and if HE says it, it's so! The hope of God being glorified is Christ in you. This is the mystery of the ages.

I have found at least 30 verses in the New Testament that validate the fact that we are made perfect because of the price Jesus paid on the cross for us. Our part now is to do as God does and exalt His Word above

everything else. "...for thou hast magnified thy word above all thy name." (Psalm 138:2)

The devil continually tries to steal our confidence and to steal the Word of God out of our hearts. The devil gives all kinds of thoughts and impressions as to why you can't have the gifts of the Holy Spirit or operate in them. One of the main things that he tells us is, of course, that we are not perfect. Also, many people feel that you have to be mature to be used of God. Well, to be perfect means to be mature. Jesus says in the Bible that we are perfect and so we are! (See Hebrews 10:14)

Another ploy the devil will use against us are things like pain, discomfort, or being given a bad report by a medical doctor when we are seeking a healing. We must learn to agree with God's Word at all costs. However, if things do not change, there are times we may need to examine our lives to see if we are missing something or if we are doing something wrong.

I can remember an incident that happened several years ago. I was pastoring a church, taking care of a farm, and selling cars, all at the same time, to help keep my church running and also do crusades. I was 39 and my 40th birthday was coming up. It was winter and I was outside on the farm carrying these five gallon buckets of grain and wading in cow manure up to my ankles. I was tired and it was early in the morning and my feet were hurting me really bad. The more I kept going and working to feed the cattle, the more my feet hurt. Finally, I put my buckets down and decided I was going to pray. So I prayed the way I would normally and then went on and kept working saying I am believing in faith for my feet to be healed.

Well, instead of feeling better, my feet began to feel worse. So I decided to pray again. This time when I prayed, I even raised my hands and prayed harder. And again, my feet began to hurt even worse. So a third time I stopped and prayed and lifted up my hands and by this time I was almost crying I was feeling so sorry for myself. I was really complaining to God. Sometimes we mix up true praying with just simply complaining to God. I said, "God this is just not right. I've prayed for thousands and thousands of people all over the world and have seen all kinds of miracles. How come Your power will not work for me?" And God answered me right then and there, not in an audible voice, but it was more real than an audible voice, and He said, "Mel, My anointing will not work for your feet." Well, I got mad. I thought, "That's not right." It works for everyone else, why doesn't it work for me? And so I complained a little while longer and then said, "Well God, how come it won't work for me but it will work for everybody else?" And He said, "Calm down, Mel, and just look down at your feet." I stopped and looked down at my feet and saw that I had both boots on the wrong feet! So sometimes we need to make some changes ourselves to achieve a desired result.

The devil is a liar and he will take advantage of us if we listen to him. We need to change our "stinkin' thinkin'" and believe the Word of God, and stop believing what man's religion has taught us or what we "think" is right and what our senses may tell us.

The Book of 1 Corinthians, in the New Testament, is written, "Unto the church of God which is at Corinth...". (1 Corinthians 1:2) It was written to one

of the major churches in Asia Minor. In verse seven of that same chapter, God is talking to that same church and He says: "So that ye come behind in *no gift*...". That means they had all nine gifts of the Holy Spirit working in their lives. The nine gifts of the Holy Spirit are referred to as signs and wonders in the Bible. As I study the Greek and Hebrew, I see the fuller meaning for the word "signs" as supernatural miracles in the sense realm proving that Jesus Christ is Lord and "wonders" to be supernatural miracles in the imagination realm validating that Jesus Christ is Lord. Amen. In other words, God is wanting us to perform signs and wonders in these last days that prove that Jesus Christ is Lord!

We need to stop fighting other religions and other churches and get into an arena that they can't compete with and that's performing signs and wonders. Instead of trying to debate with them, just let God be God and they will begin to accept Jesus as Lord.

I have been to other countries where women are not accepted unless they put all kinds of shawls over their heads and other things, but I tell you if those women start to do signs and wonders, it won't matter who it is, people will stop and take notice and begin to see God. The world is hungry for the supernatural of God. They are looking for something that's real and not just words. They are looking for a demonstration of the power of God. The Apostle Paul said in 1 Corinthians, chapter 2: "And I, brethren, when I came to you, came not with excellency of speech or of wisdom, declaring unto you the testimony of God." (vs. 1) "... but in demonstration of the Spirit and of power: That

your faith should not stand in the wisdom of men, but in the power of God." (vs. 4-5)

So as I have just shown, the Corinthian church came behind in no gift. Now I want to show you what their level of spiritual maturity was when the Apostle Paul told them that. 1 Corinthians 3:1 says, "And I, brethren, could not speak unto you as unto spiritual, but as unto carnal, even as unto babes in Christ." They were baby Christians but they had all nine gifts of the Holy Spirit in operation. They were carnal and yet they still had all nine gifts of the Holy Spirit in their lives.

To put it another way, if your father is a multi-trillionaire and you are only a month old, then you are a multi-trillionaire also. It's based on who your father is, not on who you are. When you accepted Jesus as your Lord and Savior, you were born into the Kingdom of God. You were born to be like Jesus. It's not based on how wonderful you are... it's based on how wonderful He is. The enemy will lie to you and tell you that you have to get your house in order and be more perfect and get rid of this, that, and the other, before God will use you, but it simply isn't true. God says you qualify because Jesus is your Lord.

It is true, you are much better off when you live a holy life. But some people realize this and yet they have things in their life that they know are not right and battle these things on a continuous basis. The devil then lies and tells them they cannot be everything they want to be because of the things in their life that are not right. But while sin is indeed wrong and an evil that needs to be dealt with, you need to realize that you cannot get rid of sin on your own.

Here's what you do. You let God use you. God's power is holy when it flows through you and into others. Then, as a result, your "want to's" begin to change. And the more you allow God to use you, the more holy you become and the higher quality of life you will have.

God has the highest order of quality of life. He never has a bad day. The Bible says His strength is His joy. The joy of the Lord is your strength also. (Nehemiah 8:10) The devil will lie to you and tell you that there is pleasure in sin. But who is more powerful, God or the devil? God is. Therefore His holiness is more pleasurable than the devil's sin. If that's not true then we should all just go to hell. But it is true and you can have the pleasures of divinity right now by allowing God to flow through you and use you.

Let me give you another illustration of something that helped me many years ago to be used of God. I read in the Bible where God used a donkey. (Numbers 22:28-31) God's anointing and signs and wonders supernaturally flowed through a donkey and she started talking. The power of God was manifested through a donkey! I thought, "Man, if God can use a donkey, there's room for me." Amen! Isn't that right? I have never seen a donkey get saved yet. Do you understand what I am saying? God is looking for someone who is available. He's looking for someone with availability, not ability, to be used by God. If you don't make yourself available, God will use someone else who has maybe 20 to 100 times less ability than yourself. Forget about your abilities and just make yourself available to God and He will use you.

In Mark 16:17, Jesus said, "And these signs shall follow them that believe...". Immediately as a child of God, you are equipped with supernatural power to flow in last days' signs and wonders. In other words, as soon as we believe that Jesus is the Lord and the Savior of our lives, we qualify to be used by God. But the Bible also teaches that we are at war with the devil. The enemy comes to "...steal, and to kill, and to destroy...", but Jesus came "...that they [we] might have life, and that they [we] might have it more abundantly." (John 10:10)

You need to know that even if you are a baby Christian, you are equipped to have authority over all the power of the enemy. Jesus said: "Behold, I give unto you power to tread on serpents and scorpions, and over all the power of the enemy: and nothing shall by any means hurt you." (Luke 10:19) So even a baby Christian qualifies and has power over the enemy... how much more then those of us that have been a child of God for more than five years! God is a good God!

Another hindrance I have found that keeps people from flowing in signs and wonders and the gifts of the Holy Spirit is when they try to lay hands on the sick and they don't recover. Let me share with you a little secret about that. Mark 16 says, "He that believeth..." (vs. 16) "... shall lay hands on the sick, and they shall recover." (vs. 18) Your part is to lay hands on the sick. God's part is to recover them. You are not in the recovery business. You are in the praying business. You pray and do your part and then God will do His part. I learned this valuable lesson early on in my ministry.

In 1990, I had an outdoor crusade in Mexico. There were about 500 to 600 people there. I was all fired up and just wanted to do everything the Bible says to do. And the Bible says to go out and heal the sick, cleanse the lepers, open blind eyes and deaf ears and raise the dead. So that was what I had planned to do. I hired some guys with bullhorns (portable loud speakers) to go throughout the community telling them all these things. I also had them put up banners stating all the things that God was going to do as well. I never dreamed that anyone would bring a dead person to church. I just thought it sounded good and would draw a crowd by quoting Scripture that God's power will raise the dead. (Matthew 10:8) After all, Jesus said it.

And during those years, I really liked to preach. I would scream and yell and sweat a lot. I now know that once you grab hold of the *dynamics*, you don't need any *gymnastics*. It's not how loud you scream that turns on the light switch. It's just a matter of turning the light switch on. But back then I just preached loud and strong. Since I could barely speak Spanish, I had an interpreter with me who was standing right next to me. Mexican people love emotional preaching and that's good because I was doing just that.

Then all of the sudden I see four men coming straight through the crowd carrying this lady. There were two men on each side of her. Now I had already been a pastor for several years by this time and I had been to the morgue and attended a lot of funerals so I know what a dead person looks like. And I can tell you this lady was dead. They laid her right down in

front of me. So I asked the interpreter, "What are these guys doing?" The interpreter spoke to the four men and found out that the lady had already had four heart attacks and the doctor told her if she had one more, she would die. Well, that day she had another one and she died. The interpreter then said that these four men had heard someone coming down the street with a bull-horn saying to bring the dead, so they did. They had just been waiting for the service to start to bring her up. So there she was.

I thought, "Oh, man!" I looked down at the woman and fear came all over me. She was most definitely dead! Matthew 26:41 says to "Watch and pray..." but I only did half of that. I just looked at her and thought I'm not looking any more. I couldn't watch. I just prayed. I took authority over death and commanded death to leave and I commanded life to come back into her and then I just walked away and proceeded to go down this long aisle preaching just as loud and hard as I could so people wouldn't focus on the dead lady laying up front. The devil was having a heyday with me telling me that my crusade was over and how I was in big trouble now. I've noticed that whenever you get on the right track with God, the devil will always be after you. If you are having big troubles now it's because you are getting closer to a great, great break-through and the devil doesn't want you to have it. So I just kept on going down this aisle preaching as loud as I could when all of the sudden all the people jumped up and they were not paying attention to me anymore. They were all pointing to the front of the tent. I turned around and looked and there was the dead woman standing up and dancing!

All God needs is for someone to pray the prayer of faith. He just needs someone who will pray God's Word and then He will do the confirming. (See Mark 16:20) After you have prayed the prayer of faith, you can just walk away. You have done your job.

I never forgot that lesson. I have since prayed for people with horrible, horrible situations and when I got done praying it seemed like nothing was better at all. But once I pray, I just stay in faith. Hebrew 11:1 says, "*Now* faith is...". Any time you put something off to the future you are in doubt and unbelief. If you are not in faith you are unscriptural and it will not come to pass. Simple. Let me give you an example. When Isaiah 53:5 tells us, "...with his stripes we *are* healed.", then we are healed *now*! We've got to learn that God is smarter than us! God says that His ways are far above our ways. (Isaiah 55:8-9) I am not going to be healed someday. I am healed now because the Bible says I am. God says it so it is so. If you want to take it up with somebody, take it up with God!

I have done that time and time again when people say that they are not one bit better. That doesn't bother me because I just put the deposit in there. If they choose to reject it, that's up to them. My part is to deposit the word of God in their heart and mind.

God confirms His Word with signs following. (Mark 16:20) But to do that, He needs a Word carrier. That is where you come in. You need to know the Word. But as I mentioned before, you don't need to know a whole lot of Word because this will work even for baby Christians. They come behind in no gift. All

you have to do is lay hands on the sick. God will do the recovering.

The name of Jesus is above every name. (Philippians 2:9-10) Every sickness, disease and problem has a name, but Jesus' name is above or superior to any sickness, disease or problem, whatever it may be. If the problem is sickness, in the name of Jesus, just command whatever the sickness is to leave and in Jesus' name command health to take place. God will confirm His Word with signs following. No Word, no confirmation! You are not the one who confirms, He is.

James 5:15 says that the prayer of faith will save the sick and the Lord will raise them up. Your part is just to pray the prayer of faith. You do your job and He will do His. You can't do His job. You just do what He has told you to do. Amen? *God is waiting on you!*

I want to encourage you to know that God is waiting on you. For 2000 years the body of Christ has been fasting and praying and looking for signs that happen in the sun and the moon or for another country to surround Israel to signal the return of the Lord. But God has been waiting on us to flow in last days' signs and wonders to signal the return of the Lord. Some of the other things just mentioned may take place before the return of the Lord, but not until after we do our job. Many things have been set in order in the last 1500 years for the rapture to take place, but the body of Christ has yet to do what God has instructed them to do so that Jesus could come. I have read many good books by good, valid Christian authors that pointed out things that will happen before the rapture will take

place. Then those things happened and another 100 years have gone by and still Jesus has not come.

So don't just sit around and wait for the moon to turn red before Jesus comes. Act like Jesus is Almighty God and begin to bring the masses into the Kingdom of God. As I study the Bible in the Book of Revelation, chapters 4 and 5 talk about a crowd of people that no man can number (a sea of people), and this is before the tribulation comes on the scene. They are raptured. I see, as I study the Word of God, a move of God that He wants to take place on planet earth. It is a move of signs and wonders to win people into the Kingdom of God. Then the rapture will take place.

Fear is a poor substitute for bringing people into the Kingdom of God. In fact, it is no substitute at all. I remember when the World Trade Center in New York in America was destroyed by terrorists on September 11, 2001. People became scared and the following Sunday we had instant church growth. In fact, that Sunday, every church in America had instant church growth. Everyone said the end of the world was coming. But, by the following Sunday, half of those people were gone. And sadly, by the third Sunday, they were all gone and no one could get them to come back. You can't scare someone into accepting Jesus as Lord, but you can love the devil out of them. That is what the world needs. They need the power of God to change their lives, not some scare tactics from Christians and the church.

We have the power of God. We are the representation of the Lord Jesus Christ on this earth. We are His body, the fullness of God to fulfill all in all. (Ephesians

1:22-23) We fulfill the mind and purpose of God in this world. We are called as a generation to get the job done!

Let's look at Romans 8:18. It says, "For I reckon that the sufferings of this present time are not worthy to be compared with the glory which shall be revealed in us." The Greek word for "reckon" in that passage is also rendered as the word "conclude". The Greek word for "glory" there also refers to the "reputation of God". In other words, there are sufferings that take place in a Christian's life, but they don't compare with the reputation of God that He wants to reveal in His people.

You need to know up front, when you begin to operate in signs and wonders, the enemy will attack you with all kinds of trials and temptations, even seemingly good things, to try and get you off track. I recall playing checkers with my grandpa. He was a wise old guy. He would let me win a lot of moves and then wipe me off the board! That's the way the devil does. He will give you financial opportunities, for example, that you never dreamt possible to try and get you away from what God wants you to do. If you sit under the ministry of the Word of God and follow His precepts, I can tell you, you will get wealthy, because the Word of God causes blessings. But notice what it says in Mark, chapter 4, after the Word has been sown and riches come. It says, "...these are they which are sown among thorns; such as hear the word, And the cares of this world, and the deceitfulness of riches, and the lusts of other things entering in, choke the word, and it becometh unfruitful." (vs. 18-19)

We must be cautious even of good things, like riches and natural things, that they would not be of more value to us than the things of God. It's okay to have riches. However, we must make sure that riches do not have us. The closer we walk with the Lord, the bigger the battles we will face. However, the much, much greater the victories we will have as well. You need to know that God can outdo anything the devil has to offer.

That is why it is good to memorize verses of the Bible. The devils of hell hate the Word of God. They will leave when God's Word is consistently referred to by a believer. The Bible says in James 4:7, "Submit yourselves therefore to God. Resist the devil, and he will flee from you." So many Christians do not have victory because they do not know how to resist the devil. You must submit first to God. Then you can resist the devil. You don't have to quote the whole Bible. Devils are tormented by just one verse of the Bible. They hate all of the Word of God.

All you need is one Word from God and the devils of hell tremble. A good example of this is found in Matthew 14:25-29, where Jesus walks on the water. Jesus went out to the disciples who were in a ship, walking on the sea. (vs. 25) It made the disciples afraid but Jesus said unto them in verse 27, "…Be of good cheer; it is I; be not afraid." "And Peter answered him and said, Lord, if it be thou, bid me come unto thee on the water. And he said, Come…". (vs. 28-29) And with that one Word, Peter came down out of the ship and walked on the water to go to Jesus.

Peter walked on the water with one Word, "Come." That's all Jesus said. Jesus did not preach an entire ser-

mon and didn't stop and pray for Peter or lay hands on him. He just said one Word. "Come." All you need is one Word from God and the devils of hell tremble.

Also, just use the name of Jesus, the "...name which is above every name:". (Philippians 2:9) Start memorizing the Word of God so you can be more useful in the things of God. Sin will blind you if you persist in it. But by putting the Word of God inside of you, sin will eventually have to leave. God will work with you at whatever level you are at. God is a fair God.

As I mentioned earlier, all the tests, trials and temptations are not to be compared to the glory to be revealed in us. (Romans 8:18) No matter what the devil offers or how bad the test or trial, just forget it. Blow it off. It can't compare to the glory that God has in store for you. Folks, we are in for a grand finale!

Enoch learned in the Old Testament how to walk so close with God that he was not. As I have studied what that means in the Bible, I learned that Enoch learned how to walk to Heaven. That's better than any vacation. He learned how to visit and enjoy the splendor of Heaven. Finally, he got to the place that he walked so close with God that he decided he would not go back. The Bible says they could not even find his body. (See Genesis 5:24 and Hebrews 11:5)

Hebrews 4:16 entreats us to come boldly to the Throne of God if you need help. The Greek word for "come" in this passage has the fuller meaning of "to visit literally", meaning, to actually appear. God wasn't teasing. He is telling you that you are able, when need be, to leave your body and go to the Throne of God. We

need to believe God more than what our natural senses tell us if we are going to start seeing and having more of the supernatural of God.

My wife and I have been to Heaven more than one time and it is awesome just to stand in the presence of Jesus! One time, in particular, when I went, I was just walking around Heaven and enjoying it so much I didn't want to come back. I was 39 years old and I was going through a lot down here on earth and I told everybody up there I was going to stay. In Heaven, the atmosphere alone is so awesome, supernatural, pleasing, exciting and fulfilling. You just close your eyes and enjoy the atmosphere. You don't want to go back to earth.

I'm not the only one that feels that way. One time I was asked by a particular ministry to go and pray for a little girl and raise her from the dead. She was about 12 years of age. The hospital was a little over an hour from where I lived. I had to get washed up and so by the time I got to the hospital the little girl had already been dead at least three to four hours. When I came into the room, her family and a nurse were in the room. She looked like a little angel laying in the bed. I prayed for her and the nurse verified that she came alive again by the machines that were hooked to her body. But she only lived maybe one to two minutes and then she died again. At that point, I didn't know what else to do. I loved and encouraged the family and then went back to my car to drive home.

It really broke my heart. I began to weep while driving home and I asked the Lord what went wrong. The Lord spoke to me and said she had been in Heaven

too long. She did not want to come back. A 12-year-old girl with her whole life in front of her and she did not want to come back to earth. Heaven is awesome!

Anyway, to finish my story about when I didn't want to leave Heaven, I was in Heaven walking around when I heard someone calling my name. I knew it was Jesus and I turned around. I can still see Him. He was about 75 feet away from me and just had His arms out to me and a big smile on His face. I could sense the love that He had. His love just penetrates your whole being. When He looks at you, He makes you feel like you are His best and only friend. You are that important to Him. And He's that way with everybody.

I can remember Him standing on my right side and He put His arm around me and asked how I was enjoying Heaven. I said, "Oh, it's wonderful." He said, "Well, I am glad you like it." We took a couple of more steps and He said, "I heard you are not going back this time." In my spirit, I just kind of cringed. I thought, "He's going to make me go back." He looked at me with a big smile and said, "Oh, you don't have to be concerned. I'm not going to make you go back if you don't want to." Then He said to me, "Before you make up your mind, I want to show you something." We took a couple of steps and it was like the clouds opened up and I could see through a portal on the edge of Heaven. I saw the tribulation period. I saw multitudes of people in great torment. Then I saw someone that was extremely important to me, someone that I love very dearly and she was walking with her dress all torn and filthy. And it looked as if she had been wearing the same dress for months. She was extremely dirty and

tears were flowing down her face. It was obvious that she was in great torment and great heartache. Jesus then said to me, "If you stay, you cannot help them." I knew in my heart exactly what Jesus meant. I knew that I had to help her and the multitudes of people that I had seen. If I stayed, I would not be able to help them from going through the tribulation period. I looked at Jesus without hesitation, and said, "I have to go back." Instantly I woke up in bed. It was about 3:30 in the morning.

What Jesus was saying is that, in essence, if I went back, my loved one and the multitudes I saw would go to Heaven. Heaven is real and it is awesome. Before the rapture takes place, the Bible tells us that everything God has done in the past and the present is going to be happening in the last days. People will have visitations from the angels of Heaven and we are going to begin to experience supernatural things. I've already begun to see these things in the last few years. It's getting easier and easier. Sometimes the miracles are so awesome, it seems I am dreaming while standing in front of a group of people in a church service. Seeing things such as a body that's all deformed and an eyeball that's down on the lower side of a little girl's cheek and then no eyeball at all on the other side of her face. And then, as I watch, her whole face is recreated. God's miracles are so supernatural, our natural minds sometimes cannot comprehend fully what is happening. It seems like a dream. I tell you the devil's best is garbage compared to the glory that God wants to reveal in and through you. AMEN!

Romans 8:19 says: "For the earnest expectation of the creature waiteth for the manifestation of the sons of God." The word "creature" is co-equally rendered in the Greek as the "Creator". God is our Creator. God is waiting for the manifestation of the sons and daughters of God. He is waiting on us! You need to know that God is waiting on you to manifest God's miracle working power on the earth.

My job as a pastor, and any true pastor's or preacher's job, is to train and equip you to do the works that Jesus did. (Ephesians 4:11-13) Church is to be a training ground for Christians to begin to do what Jesus did. As Christians, we are then to go out and just act like what the Bible says is true. Just do it! Just remember, HE does the recovering. And as I said earlier, when you first start operating with the gifts of the Holy Spirit, the devil will work hard to try to frustrate and discourage you and try to kill your confidence. Just don't forget... God does the recovering, not you.

So God is waiting on us! "For we know that the whole creation groaneth and travaileth in pain together until now." (Romans 8:22) In the Greek, the last few words there are "...until this time." All of creation is groaning and travailing knowing that there is something more in existence. They are groaning and travailing in their spirits for God's people to manifest great signs and wonders, validating that there is an Almighty God and that He is "...the way, the truth, and the life...". (John 14:6) He is the way into a fuller life. People are yearning for something that is real. The people in the world are filling their lives with all sorts

of things hoping to satisfy the emptiness that they have in their spirit. We have what they need.

When God's people begin to give this world the supernatural of God or God, then by the multitudes they will start following us to church. They will also follow us to Heaven. There is a deep cry in each one of us that says there has to be more. When that emptiness is filled with God's presence and fullness, then it will no longer be just a form of Godliness, it will be the power of God.

We are in a time when all around the world people are hearing all kinds of religious teaching and it is all dead. It only has a form of Godliness but no power. We need to show them that our God is not just all talk. He has the power. That's the difference and we've got it! In Romans, chapter 8, we read: "And not only they, but ourselves also, which have the firstfruits of the Spirit, even we ourselves groan within ourselves, waiting for the adoption, to wit, the redemption of our body." (vs. 23)

God is saying that our mortal bodies want to be swallowed up with His Glory. Look in 2 Corinthians 3:17-18: "Now the Lord is that Spirit: and where the Spirit of the Lord is, there is liberty. But we all, with open face beholding as in a glass the glory of the Lord, are changed into the same image from glory to glory, even as by the Spirit of the Lord." What this is saying is that the more you keep reading the Word of God and keep reading the Word of God, the more you are changed into His reputation or glory.

Let's look at it this way: I do not look the same way midday as I do when I first get up. What I do first thing

in the morning is look in the mirror and I say, "Buddy, you need some help." So, I change the way I look by looking in the mirror. I know I need to comb my hair, shave off some whiskers and brush my teeth. I change myself by looking in the mirror. The Bible is God's mirror. He wants you to look into it and see yourself as He sees you. And He sees you with His reputation. That's why you need to keep reading more and more, because you gain more confidence when you do. We do not read the Bible to earn, we read to learn. We are learning what's ours based upon what God says belongs to us.

In Matthew 15:1-9, Jesus clearly teaches us that the commandments of God are made of no effect by the traditions of men. There are many people in this world that read the same Bible that we read, and yet, because of the traditions of men, have very little of God's power and blessings working in their lives.

Some of the most evil people that ever lived have used Bible verses to validate things they want to believe in. They say Hitler read the Bible a lot. The devil knows the Word of God extremely well. James 2:19 says that the devils believe in God and His Word and tremble. The devils of hell want us to know God's Word from a demonic standpoint and that is exactly what the traditions of men are. The traditions of men twist the Word of God and take the unconditional, miraculous power of God out of it. God, on the other hand, wants us to know His Word and obtain the knowledge to access God's power, unconditional love and grace.

I firmly believe that we should read our Bibles every day. I also believe we should memorize Scriptures.

I could write a book giving many Scriptures showing the supernatural benefits of reading and memorizing God's Word. You need to know that we have already been given everything that pertains to this life and God-likeness. (See 2 Peter 1:3-4) But we must understand that when we read and memorize God's Word, we are not doing it to EARN, but to LEARN, all that is given to us by God. Or you could say it this way: God's Word is like a gold mine that has been given to us. The more we dig into it, the richer we become.

I want to tell you of an experience I went through that shows satan's strong desire to get people into man-made religious works of the flesh. 2 Corinthians 3:6 tells us plainly that "... the letter killeth, but the spirit giveth life." The same Bible used by the influence of the devil to bring about death by the traditions of men, when influenced by God, causes life or the power of God to operate in our lives. It's simple really. Again, we need to read to learn, not earn, the power of God.

I went through a period of time where the devil lied to me and told me to read the Bible more and that if I did, I could *earn* more of the power of God. He kept telling me that if I would fast and pray I would *earn* more of God's power. This went on for several months. I thought it was the Holy Spirit telling me this, but it was a lie of the enemy. So I began to read my Bible at least twice as much as I normally did on a daily basis. I did this for two to three months but things only got worse and I got more depressed. Then, after a period of time, I felt pressed in my mind for several days that now I needed to fast. So I started fasting and did so for several days. But still, things only got worse. So I was

very depressed and angry. I said within myself, "I am not going to read the Bible any more and I am going to eat whatever I want." In fact, I was so upset that I had decided to get totally out of the ministry.

Then one night, about 2:00 a.m., while I was asleep in bed, I heard a noise coming from the living room. It sounded like the feet moving of a heavy person on our carpet dragging his feet. The steps came down the hallway and into our bedroom. It caused me to become very wide awake. This was not a dream. I watched as the round door knob to our bedroom turned and in walked the devil right into our bedroom!

When the devil walked in, I rebuked him. I said "In Jesus' name, I command you to leave." He just grinned with a devilish grin, and said, "God told you to fast and pray and read your Bible twice as much as normal and you are not doing it!" After that came the thought, "You are powerless because you are not doing what God told you to do." I wondered, "How did he know that?" The devil then paralyzed my whole body until he left. I remember trying with all of my strength just to move my little finger on my right hand, and I could not. My body was totally overpowered by the power of the devil. The devil then just started laughing and then disappeared into thin air.

After this experience, I was so depressed. I felt like a worm was ruling over my life. And that is an accurate description because satan's name means "beelzebub", which literally means, "lord of the flies", and a fly is a full grown maggot. I don't think I've ever felt so depressed in my whole life and I went on in that depression for about two weeks. How would you like a mag-

got to be your boss? That's the way I felt. I could hardly sleep, I was so miserable during those two weeks.

Then one night I got out of my bed because I couldn't sleep and I went and laid on the floor and cried out to God and said in so many words, "God, You know me. You know I will do anything You ask me to do. No matter how dangerous or what it might be, I will do it. Just tell me please what You want me to do!" I forgot all the thee's and thou's in the Bible and I just talked to the Lord with child-like words. I do not know how long I prayed, but eventually I sensed God and all His fullness near and around me. I did not see Him or hear Him but I knew He was there.

Then God said to me that I do not have to read the Word, pray or fast to "earn" His love and His power. This is what He said: "Mel, I want to tell you something. You are My child because Jesus died on the cross and rose from the dead. It's not based on anything you've ever done or ever will do. You have authority over the devil and all the pits of hell because you are My child, not because of anything that you could do." I'm telling you, when He said that, it felt like there was a heavy weight lifted off of my back literally.

For the next two weeks I didn't read the Bible unless I wanted to and I didn't pray unless I wanted to. I just simply enjoyed life and enjoyed the goodness of God. About two weeks later, I heard that same noise in the living room moving toward our bedroom. I was wide awake again and it was the devil same as before. Only this time I sat up in bed and I said, "Satan, I rebuke you in Jesus' name." The devil tried to tell me I couldn't because I had not been reading my Bible two

hours a day, praying two hours a day or fasting. Only this time I spoke to him with authority and I said, "Satan, I have authority over you in Jesus' name because I am a child of the living God, not because of anything I have ever done or ever could possibly do." He grinned as before but this time it was very evident that he was forcing a fake grin on his face. Then he totally vanished into thin air.

I now know firsthand what a wonderful experience it is to live in God's presence and love on a daily basis. It's a shame we do not get into His presence and stay there. God says we can! It's called walking in the Spirit; walking inside of God. (See Galatians 5:16)

Yes, we should read our Bibles to *learn* what is ours. Reading the Bible deposits great wealth and supernatural, divine influence into our lives. But we must understand that we cannot read the Bible or do anything to *earn* what God has already given us. That is a trick of the devil.

2

TAKE TIME TO STUDY GOD'S WORD

In my book, *Mystery Of The Ages*, I refer to over 700 verses that clearly teach that God has already "...given unto us *all* things that pertain unto life and godliness...". (2 Peter 1:3) Again in Romans 8:32: "He [God] that spared not his own Son, but delivered him up for us all, how shall he not with him also freely give us *all* things?" These are just two such verses that plainly teach that God has already given us *all* nine gifts of the Holy Spirit. He has already given them to us. We just need to receive them.

I have been to some 35 different countries throughout the world, and every place I go, I have heard people talk about a false doctrine that says you only get one gift. There is only one small section of Scripture verses in the whole Bible that makes it look like you only get one gift and that is in 1 Corinthians 12:8-10. So what do we do with these few Scriptures and why has it been exalted above the other 700 passages of Scripture that teach we have all nine gifts of the Holy Spirit? The reason is very clear. The devil doesn't want you to operate with the power and fullness of God because

this is the major thing that God wants to happen in the last days to win the masses to the Lord. In most of the churches where the "one gift only" false doctrine is taught, most, if not all, of the people there, do not have *any* gift in operation much less one gift. This is so crippling to the body of Christ.

To validate what I am saying, we need to look at some things. I have, in my possession, 31 of the best and most accurate translations and versions of the Bible. I have had them for years and I study all of them. Since the age of 17, I have especially studied the King James Version of the Bible and I find that the King James Version is the most accurate.

I know, some people say they do not understand the King James Bible because it uses the words "thee" and "thou" in it. That's just another ploy of the devil to keep us from reading the most accurate version of the Bible. Because Elizabethan English is no longer spoken today in the United States, people read the King James and use the excuse, "I do not understand what is being said." However, let's be honest and take a look at the major words that we do not use today.

When the Bible says, "Thou shalt not kill.", that's pretty simple. There, the "thou" is "you". You shall not kill. It's really understood. There are some mistranslations in the King James Bible but none of them that would affect your eternal salvation. However, there *are* some mistranslations in the King James Bible and we need to be intelligent and realize that.

One such mistranslation is found in Romans 8. In verses 16 and 26, the Scriptures refer to the Holy Spirit

as an "it". Common sense, as well as having just a little bit of reverence for God, tells us this is a mistranslation. God, the Holy Spirit, is not an it! In verses 16 and 26, the word "itself" is the Greek word "autos" which is rendered as "itself, him or himself". The translators, in these two cases, chose the word "itself" over the accurate translation, which should be "himself". I only bring this out to validate that there are some minor mistranslations of the Bible.

The worst mistranslations have to do with words in the original language that can be used for god or God or lord or Lord. Many times in the Scriptures, in the original language, these words can be used interchangeably. It becomes wrong when it is translated to make it look like God did something evil. I have a book that I wrote a few years ago, but have not put it into print just yet, but will be doing so shortly, that is entitled: *God Is Good All Of The Time*. In this book I deal in detail with this subject of verses that make God look like He did and does evil things. In it, I clarify that God is only good. When you read something in the Bible that doesn't add up, study it out. Something is wrong. You can rest assured that a word or two has been mistranslated.

The devil doesn't want you to know the truth. And the mistranslating of some words in the Bible is one of the ways the devil keeps you from knowing the real truth. He doesn't want you to flow with all the gifts of the Holy Spirit because it will supernaturally change your life and change the lives of many other people as well. I am in the process, for the fifth time, of going from Genesis to Revelation finding every verse and/or

word in the Bible that doesn't match the original language of the Word of God.

Jesus mentions in Matthew 15:6 about the traditions of man making the Word of God of no effect. The traditions of man will cause God's Word to become of no effect. They are false claims that have been taught as the truth.

So, getting back to 1 Corinthians 12, there are only three verses, (vs. 8-10), that make it look like we do not get all the gifts of the Holy Spirit. In verse one of 1 Corinthians 12, it says, "Now concerning spiritual gifts, brethren [or sisters], I would not have you ignorant." So here God is saying that He wants us to know about and understand the gifts of the Holy Spirit. Then if we drop down to verse four, it reiterates that there are diversities (meaning varieties) of gifts. Verses one through seven of 1 Corinthians 12, then, is an introduction to all nine gifts of the Holy Spirit. In verse seven it says that, "...the manifestation [the Greek word there for "manifestation" is "phanerosis" which is co-equally rendered in the Greek as "exhibition, expression and bestowment"] of the Spirit is given to every man [the Greek word there for "man" is "hekastos", which is co-equally rendered as "each one and every woman"] to profit withal." So God has already given all nine gifts to the whole human race. That includes even the worst sinners on the face of the earth. They just need to get saved and then they can discover the gifts and use them also.

As you read the closing statement of the nine gifts of the Holy Spirit, in 1 Corinthians 12:11, you can again see clearly that all nine gifts are given to every person.

Verse 11 says: "But all these worketh that one and the selfsame Spirit, dividing to *every* man severally as he will." As you study God's Word, you will find that God's Word is His will. This is brought out clearly in the Book of Ephesians. So we see that God's will is that He wants everyone to have all of the nine gifts of the Holy Spirit. As a man or a person gets their will in agreement with God's will, all nine gifts of the Holy Spirit will be made manifest in that person's life.

Notice in 1 Corinthians 12, verse 11, where it says that the, "...Spirit, dividing [divides] to every man severally as he [meaning the person] will[s]." In the English language, the word "he" is a pronoun which always refers to the closest noun previous to it, which in this case is "man". So what this is saying is that as a man (or a woman) gets his or her will in agreement with God's will, the gifts are made manifest in and through that person. In other words, the decision is yours!

You can have all the gifts that you desire to have. If you don't want some of them, that's okay too. Some people may not want the gift of the working of miracles, they may not desire it. And so that gift will not be in operation in their life. However, there may come a time when that particular gift is needed. If you came upon a car accident, and let's say there is a little girl lying dead or dying on the highway and your heart goes out to her, you could activate the gift of the working of miracles and the gift of faith to bring her back to life. Amen.

I've been doing crusades for a long time. I began preaching when I was 17 and started doing crusades

33

right away. I would go to places throughout the United States and do crusades, but I never really saw any healings or miracles take place. We would have services with 300 to 400 people present, but nobody got healed or saved. And I mean nobody! But when I learned to flow in the gifts of the Holy Spirit, in the supernatural of God, especially in healings and the working of miracles, I noticed a dramatic difference in people getting saved. There is just no comparison.

It's easy to get people saved when God's supernatural atmosphere is operating. People can feel the atmosphere. It validates that we serve an Almighty God, and people are looking for something that is real. It's amazing! I remember one time in India when we had over 30,000 people accept Jesus as Lord in one service and 50% of them were Muslims. All because of miracles, signs and wonders! Some people come as skeptics. In fact, my life has been threatened a few times. I've had people say to me that they were going to kill me if I didn't leave. All I said back was, "Well, God didn't tell me to leave." I knew God would take care of me. Many of the skeptics that came to our services over the years to prove that Jesus Christ is not real, instead ended up giving their lives to the Lord. Miracles, signs and wonders are the catalyst for the end times' great, great move of God on the face of the earth. We are going to see it! There will not be buildings large enough to contain it. And God wants you to be a part of it too!

I spent a lot of money to go to Bible College. Donna and I did not have the money to go to Bible College but we just did it because we were hungry for more of God. We sold what we had, I quit my job, and we

moved across the state to go to Bible College. In those days, the Bible College I went to was considered the best Full-Gospel Bible College in the world. However, the Bible teaching that I received did not help me at all to flow in even one of the gifts of the Holy Spirit. They did not teach us to walk in the power of God. In those days, I would gladly have spent thousands and thousands of dollars and gone around the world, even if I had to borrow to do it, to learn how to flow in the supernatural of God and all nine gifts of the Holy Spirit.

Back then, Donna and I had just enough money to have food to eat. We bought only one gallon of gas at a time. But somehow I would have gotten the money, even if I had to borrow it, as I said, to learn what I know now. So I can say this with confidence in God's Word, that if you are born again and filled with the Holy Spirit, with the evidence of speaking in tongues, there is no reason why each and every one of you cannot operate in all nine gifts of the Holy Spirit. There is no reason. "...ye shall know the truth, and the truth shall make you free." (John 8:32)

So now, I want to encourage you to comprehend and receive all nine gifts of the Holy Spirit. But before I do that, I need to let you know it's important to be filled with the Holy Spirit with the evidence of speaking in tongues. As I study the Bible, 100% of the people in the New Testament that were filled with the Holy Spirit spoke in tongues. Some people may say, well what about John the Baptist and his mother and father? The Bible says they were filled with the Holy Spirit and it does not say they spoke in tongues. The New Testament did not start until the Book of Acts 2:4: "And they

were all filled with the Holy Ghost, and began to speak with other tongues, as the Spirit gave them utterance." In the Old Testament, only a select few individuals were chosen to have the experience of being filled with the Holy Spirit. The Holy Spirit would come down and certain ones would be touched by God for a particular work, and when that work was completed, then that experience of the Holy Spirit left.

However, in the New Testament, the Bible says of the Holy Spirit, that He will dwell in us. (John 16:7) We will be His temple. (1 Corinthians 3:16) He stays not just for a particular work, but 24 hours a day. We have that privilege when we are filled with the Holy Spirit.

If you look in the Book of Ephesians, chapter 5, verse 18, it admonishes us to "...be filled with the Spirit;". In the Greek, those same words are interpreted as "...be replenished with the Holy Spirit;". In essence, it is not a one-time experience, but a continual experience. It's sort of like drinking water. We need to continually drink water throughout all our days. To be filled with the Holy Spirit is to continue on a daily basis speaking in God's Heavenly language, being filled with His fullness and filled with His joy.

Just because you spoke in tongues ten years ago is no sign that you're filled with the Holy Spirit now. If you spoke in tongues yesterday, and you do not speak in tongues today, you are not filled with the Holy Spirit. If you want to stay vibrant with God, you need to speak in tongues quite often. And you can do that by speaking to yourself and to God in your Heavenly language. So sometimes it is just in your spirit, or on the inside, that you may be speaking in tongues.

I have a set of teachings that might help you on this subject called, *31 Reasons Every Believer Needs To Speak In Tongues*. It will help everyone in their life and walk with God. And if for no other reason, in John 7:39, Jesus said "...they that believe on him should receive..." the Holy Spirit. In that same passage, He went on to say that the Holy Spirit was not yet given because Jesus had not yet been glorified. He was talking about the coming of the Holy Spirit. Jesus, at that time, was the manifestation of God in the earth. After Jesus finished His work on earth, He would then leave and it then became the dispensation or area of time for the Holy Spirit to be the God–agent in the world. And that is the dispensation we are now in: the dispensation of the Holy Spirit. Jesus said, when the time of the Holy Spirit is come, those that believe should receive. We could close the Book right there. If Jesus said we should receive, then we should!

As I study the Bible, I see there is a subsequent experience after being born again and believing in Jesus as your Savior, and that is being filled with the Holy Spirit with the evidence of speaking in tongues. When you are born again, you have a Christ-like Spirit, but if you are filled with the Holy Spirit, you will speak in tongues. In all of the New Testament, everyone that was filled with the Holy Spirit spoke in tongues. Someone may say, you mean I have to? No, I mean you get to! It's something that builds up your life. There are more valid, Scriptural reasons why we should speak in tongues, but like I said earlier, we could simply close God's Book and say the case is closed, with the statement that Jesus made, "...they that believe on him SHOULD receive...". (John 7:39)

1 Corinthians 14:4 tells us: "He that speaketh in an unknown tongue edifieth himself...". That's a very important reason to speak in tongues. In our life, the word "edify" in the Greek means "to build up" or to charge. It's like a car battery. I don't know what state you all are from who are reading this book, but in Missouri, where I live, it gets cold in the wintertime. And if you haven't started your car for a while, the elements will come against that battery, and it will go "Rrr, rrr, rrr, rrr" when you put the key in the ignition and try to start it. It's not going to start. But, if it has been charged, even if it gets down to ten degrees, your car will start. Well it's the same way in our spiritual life. The devil and demonic forces come against us all the time. That's the reason we need to speak in tongues all the time, to keep our spiritual battery charged.

The Apostle Paul said, "I thank my God, I speak with tongues more than you all:" (1 Corinthians 14:18), meaning, more than all the church at Corinth. Clearly he was doing a lot of speaking in tongues. Sometimes, even while I'm brushing my teeth, I'll be speaking in tongues. It's not because I'm trying to earn something. I am just using what God has given me. I want to stay happy, don't you? I want to stay built up so that when the storms or elements of life come against me, I can just brush them off or push them away. Those are some additional reasons we need to speak in tongues.

In the Book of Luke, chapter 11, verse 13, Jesus makes this statement: " If ye then, being evil, know how to give good gifts unto your children: how much more shall your heavenly Father give the Holy Spirit to them that ask him?" Jesus said earlier in that same

chapter, "If a son shall ask bread of any of you that is a father, will he give him a stone? or if he ask a fish, will he... give him a serpent?" (vs. 11) "Or if he shall ask [for] an egg, will he offer him a scorpion?" (vs. 12)

I want to validate some things here. This information will also help you in praying for people to be filled with the Holy Spirit. God does not lie. If God said if you ask He will give, then He will give! The next step is for the people who are asking to just receive the Holy Spirit. This gives people confidence that anyone desiring to be filled with the Holy Spirit with the evidence of speaking in tongues only needs to receive after they have asked.

While we are on the subject, let me bring out another fact that will help you. In Luke 11:13, where Jesus says, "...how much more shall your heavenly Father give the Holy Spirit to them that ask him?", the word "ask" in that passage is the Greek word "aiteo" and the fuller meaning is to "crave, desire, and/or require". So the person that wants to be filled with the Holy Spirit needs to be really hungry for this experience. They need to crave it until it becomes a requirement in their life. Notice that Jesus put a lot of emphasis on the different types of things that a son would ask of his father. He makes it clear that a father would not give the son something that is evil. He said a father would not give a serpent to a son, if the son asked for a fish. A serpent is referring to something evil. And a father will not give a scorpion to his son if he is asking for something good. A scorpion refers to something that's evil and demonic. This is something that God guards highly. When you ask for the Holy Spirit, God's going

to make sure the devil doesn't get in there and give you something that's fake. And God will make sure that what you get from Him is the real deal.

But just so you know, many times when praying for people to be filled with the Holy Spirit, the enemy will come and try and thwart the purposes of God. Whenever the Word is sown, regardless of what it is, the enemy will show up. You start believing God for finances and I promise you, you're going to have financial problems. It will just happen. But if you just hold on to the Word of God, and remember this little cliché, "The darkest hour is just before the dawn.", you will have the victory in whatever area it might be. When the Word is sown, satan comes immediately to try and steal the Word. So if satan is not coming, then you do not have much of the Word, because when the Word is sown, the enemy will come. In the example I just gave about finances, I guarantee you, you will begin to have more financial problems than before when you begin believing and standing on the Word. But, in the end, you will have greater financial prosperity than you ever thought you would have.

Here's what you need to do when the devil comes. Say out loud: "Well, I knew you were coming! That's a good sign. That lets me know that I have it." If a thief breaks into your house, and he comes up to you and he says, "Give me that gun!", if you do not have a gun, the thief would be stupid and ignorant to ask you for it. However, if a thief breaks into your house and you've got a rifle, and the thief says to you, "Now you know you are not going to hurt me. You know you're a good person. Why don't you just give me that gun?" Well,

the only reason he would say such things is because of the fact that you've got a weapon that will destroy him. A thief is not going to try and steal something that you do not have. But when you've got it, that's when he tries to steal it.

So when the devil comes to you and says, "You're not speaking in tongues." or "That's not of God.", you can be assured that you have received. The devil comes to steal. (John 10:10) Before anything can be a reality in the natural world, it's first a reality in the spiritual world. I just say, "I'm not going to get my finances, I've got them NOW, devil." So, again, when the enemy comes, it is only because of the fact that you've got something. If you don't have anything, the devil is not going to bother you.

Another thing the devil will lie and tell you is, "You are just repeating what somebody else said." If that was the case, you would be receiving something that is fake and something that is fake is something that is only of the devil, and so that's a lie! God said if you ask for the Holy Ghost, He will make sure you don't get something that is fake or of the devil. The devil may say you are just repeating what somebody else said or that it is just words out of your natural mind. But it is impossible to repeat another language instantly.

My cousin, Inga, is a full-blooded Lakota Indian and can speak some Lakota. If I had her stand before you and say "God bless you.", in Lakota, even if she said it more than one time, you would not be able to repeat it right away, and it is only one little phrase. I demonstrated this fact one time in a signs and wonders seminar that I held at my church.

It's impossible to learn a language that quick. It's impossible. I can speak some of about five different languages and I'm still learning English. I know phrases in other languages. In learning to speak other languages, I would memorize different phrases. I wrote them down and went over them again and again until I had them memorized. People cannot speak any language by hearing it only a few times. It takes a lot of effort over a period of time. However, God's Heavenly language (speaking in tongues) is received instantly, and flows fluently. If the devil tries to tell you, "That's too simple!", just say, "Yes, that's right. If it's not simple, God is not involved in it!"

3

THE THREE UTTERANCE GIFTS

So now let's discuss the nine gifts of the Holy Spirit. I am going to break them down into three distinct, different categories. The three categories are as follows: 1. The Three Utterance Gifts; 2. The Three Power Gifts; and 3. The Three Revelation Gifts.

The first category or the utterance gifts category is a category where a person speaks. They say something. The utterance gifts category consists of the gift of tongues, interpretation of tongues and prophecy. The second category is the category of the power gifts and these gifts do something. The power gifts consist of the gift of healing, working of miracles and the gift of faith. And last, but not least, the third category is made up of the revelation gifts and these gifts reveal something. The revelation gifts category includes the discerning of spirits, the gift of the word of knowledge and the gift of the word of wisdom.

Let's now examine the three "utterance" gifts of the Holy Spirit. The three utterance gifts, as I mentioned briefly, are: 1. Speaking in Tongues; 2. Interpretation of Tongues; and 3. The Gift of Prophecy. In 1 Corinthians

12:10 we read: "...to another divers kinds of tongues; to another the interpretation of tongues:" is given.

The Gift Of Tongues

The gift of tongues is given to everybody. In Acts 2:4, we see that the gift of tongues was the sign of a new dispensation, meaning a new period of time. We are still living in that new period of time today. Jesus told His disciples to wait until they were filled with the Holy Spirit and that they would receive power when the Holy Ghost was come upon them. "And, being assembled together with them, commanded them that they should not depart from Jerusalem, but wait for the promise of the Father, which, saith he, ye have heard of me. For John truly baptized with water; but ye shall be baptized with the Holy Ghost not many days hence." (Acts 1:4-5) Again, "But ye shall receive power, after that the Holy Ghost is come upon you: and ye shall be witnesses unto me both in Jerusalem, and in all Judea, and in Samaria, and unto the uttermost part of the earth." (Acts 1:8)

And so it was just as Jesus said. "And there appeared unto them cloven tongues like as of fire, and it sat upon each of them. And they were all filled with the Holy Ghost, and began to speak with other tongues, as the Spirit gave them utterance." (Acts 2:3-4) When the new dispensation came, there were 120 devoted followers of Christ, including his 11 disciples, in an upper room waiting to be filled with the Holy Spirit with the evidence of speaking in tongues. Acts 2:4 says they were all filled with the Holy Spirit and spoke in other tongues.

44

I want to point out that you have to do the speaking in tongues. The Holy Spirit will give you the utterance (the influence), but you have to open your mouth and do the speaking. Many people miss out on this experience because they think about the utterance they are to speak. That is the way people speak in their own vernacular, meaning language or dialect spoken by people in a particular country or region. However, God is not an intellect. He is a Spirit and His language is of the Spirit world. You do not have to think about what you are saying. You simply, in faith, speak the vowels, syllables or words, a speech sound made by the vocal cords. The Holy Spirit will give you the utterance, but you don't need to think about what you are saying. Just begin to speak.

Again, speaking in tongues is for everyone. Jesus said if anyone thirsts for more of God that they should be filled with the Holy Ghost. "In the last day, that great day of the feast, Jesus stood and cried, saying, If *any man* thirst, let him come unto me, and drink. He that believeth on me, as the scripture hath said, out of his belly shall flow rivers of living water. (But this spake he of the Spirit, which they that believe on him *should* receive: for the Holy Ghost was not yet given; because that Jesus was not yet glorified.)" (John 7:37-39) In every place in the New Testament, from Acts to Revelation, everyone that was filled with the Holy Spirit spoke in tongues.

Jesus was the God–agent during the time that He was on earth. However, Jesus talked about the dispensation or time period in which the Holy Spirit would be the God–agent in the earth, and that all that believe

should receive. If John 7:37-39 were the only passages in the Bible, they would be strong enough grounds for everyone to speak in tongues, because in them He said, "...they that believe on him should receive...".

Peter was one of the people that was filled with the Holy Spirit with the evidence of speaking in tongues in Acts 2:4. He then spoke to others that had not received the gift of the Holy Spirit in Acts 2:39. Peter said: "For the promise is unto you, and to your children, and to *all* that are afar off, even as many as the Lord our God shall call." The word "shall" used there is the single Greek word "an" which is also rendered as "wish".

God is calling all unto Him. We see this in 2 Peter 3:9 which says, "The Lord is not slack concerning his promise, as some men count slackness; but is longsuffering to us-ward, not willing that any should perish, but that all should come to repentance." He is also telling all of us to desire spiritual gifts. "Follow after charity, and desire spiritual gifts...". (1 Corinthians 14:1) In verse 5 of 1 Corinthians 14, God says: "I would that ye *all* spake with tongues...". God is saying that he wants us *all* to speak in tongues. 1 Corinthians 14:39 reiterates: "...forbid not to speak with tongues." Just these few verses validate the fact that God wants everybody to speak in tongues. That is the gift of tongues.

In 1 Corinthians 14:5, you may have noticed that it not only says that God wants us all to speak in tongues, "...but rather that you prophesied...". The Greek translation of this passage gives a fuller and clearer meaning to this Scripture. The Apostle Paul is not saying that prophecy is better than tongues. He is not saying to skip tongues and just go to prophecy. He is not

46

saying that at all. In the Greek, the word for "but" in verse five has the fuller meaning of, "also, moreover, nevertheless". The word "rather" is the Greek word "mallon" which has the fuller meaning of "more (in a greater degree)". So 1 Corinthians 14:5 is more accurately rendered as, "I would that ye all spake with tongues, nevertheless, there are more gifts, there is the gift of prophecy: for greater is he that prophesieth than he that speaketh with tongues, except he interpret, that the church may receive edifying." In other words, the gift of tongues with the interpretation of tongues is equal to the gift of prophecy.

There may be times in a service when there is no one there with the gift of ministerial tongues and the gift of interpretation of tongues, but there may be someone there with the gift of prophecy. In that case, the church service may be edified with the gift of prophecy. An accurate statement about verse five is that tongues are the doorway into the supernatural.

Diversities Of Tongues

The Bible talks about the diversities of tongues in 1 Corinthians 12:28. Diversities of tongues means different kinds of tongues. There is a gift of tongues that is for everyone. This is the initial experience and evidence of being filled with the Holy Spirit that is for everyone. This type of speaking in tongues is extremely simple. A person that is a born again Christian, (Jesus Christ is the Lord of their life), will simply start speaking the utterances of God's Heavenly language. 1 Corinthians 14:15 talks about this tongue. It is as simple as speaking in a person's normal language. We can speak

in our native language any time we want to. If we are a born again Christian we can also speak in this Heavenly language (tongue) any time we want to.

As I study the Bible, however, I find there are several manifestations of speaking in tongues and all of them have a divine purpose. All of these tongues have the prerequisite of the simple gift of speaking in tongues. I have a teaching on CD of 31 different Scriptural reasons why everyone ought to speak in tongues. Each reason enhances our lives divinely. However, I again wish to make the statement that if the only reason we should speak in tongues is because Jesus said we should, that alone is reason enough. "...But this spake he of the Spirit, which they that believe on him SHOULD RECEIVE...". (John 7:39) We will now examine some of the different supernatural, divine tongues that God has ordained for born again Christians to have.

The Gift Of Tongues That Turn You Into Another Person

There is another tongue or divine language that we cannot speak just any time we want to. This type of tongues comes from being extremely hungry and earnest before God. This type of tongue turns you into another person. 1 Samuel 10:6 speaks of this experience in reference to Saul: "And the spirit of the Lord will come upon thee, and thou shalt prophesy with them, and shalt be turned into another man." It teaches clearly that when the Holy Spirit comes upon a man or a woman they are turned into another person, and you then have the divine supernatural ability to do whatever needs to be done.

48

This type of tongue is of a deeper speech as recorded in Isaiah 33:19: "Thou shalt not see a fierce people, a people of a deeper speech than thou canst perceive; of a stammering tongue, that thou canst not understand." I have noticed that when I go into this tongue, I am unaware of the natural world. There have been times when I speak in this tongue that my spirit leaves my body and I go to Heaven. This type of tongue causes a person to be more aware of the supernatural of God as well as causing God's holiness to radiate more in a person's life and make them have a greater sense of the supernatural gifts of the Holy Spirit.

As I mentioned earlier, a person can only receive this type of tongue by being extremely hungry and determined to receive more from God. In old Full-Gospel churches they had a real good understanding of this type of experience. We would generally have these type of services on a Sunday night. People would either come down to the front of the church or turn in their pew and pray with determination. They would say to themselves, "If I have to pray all night long to receive this experience, I will pray with my whole heart UNTIL I receive it!" There are times we would pray until midnight or one o'clock in the morning. After a person received this type of experience, you could actually see God's glorious glow on their face.

Back in those days, people called this experience praying through. It was like you were going through a doorway into another world. Actually what would happen is that you would pray with your whole heart until you went from one type of life into another.

49

I can remember one particular time I did not attend one of these Sunday night services. The next evening, my wife and I went to my brother and sister in-laws' house, who had been at the Sunday evening service. As soon as I walked in the door, I knew my brother-in-law had received this experience in the Sunday evening service. He had prayed through. He was through with the old carnal lifestyle and was now ready to live a more Godly lifestyle. He had prayed until he was out of the flesh and into more of the Spirit.

This type of praying meant you prayed until you were through with the world's worries, cares or affairs. You would be turned into another person. This type of experience causes more of a reality of God. It also gives a foundation of Godly values and fulfillment that you never forget and sets a foundation of Godliness in your life. This type of tongue praying should not be just a one-time experience. I heard an expression years ago that is so true. It is easier to pray through every day than it is once a week or once a month. If you live in the Spirit it is much easier to have your spirit control your flesh.

Someone may ask, which tongue is the most important? Well, let me ask you this? Which one of your eyes is the most important? You need them both.

The Gift Of Tongues Of Thanksgiving

There is another type of spiritual divine language or way of speaking in tongues that has to do with thanksgiving. We find this type of tongues in 1 Corinthians 14:16-17: "Else when thou shalt bless with the

spirit, how shall he that occupieth the room of the un-learned say Amen at thy giving of thanks, seeing he understandeth not what thou sayest? For thou ver-ily *givest thanks well*, but the other is not edified." The Greek word for "well" in this verse is "kalos" which is co-equally translated as, "truly, excellently, nobly, commendably, honorably, rightly, so there is no room for blame, magnificent". When a person worships God in this Heavenly language, they are actually giving God thanks on His level; a supernatural, divine level. The Greek says that this type of thanksgiving is right. You cannot get any more right than to have the Holy Spirit speak words of God's divine language through you. It is a type of thanksgiving that is blameless, fault-less and divinely perfect.

The Gift Of Ministerial Tongues

Another type of tongues is ministerial tongues. This is usually done in a church setting or where there is a group of people that God wants to minister to. These tongues are not given to benefit an individual, but a whole group of people. It is more rightly called preach-ing. You can always tell the difference between minis-terial tongues and other tongues. Ministerial tongues are of a higher authority, louder, and have a greater public boldness to them. It is a direct Word from God that clearly demands the attention of the people that hear it. It is easy to perceive what God is saying. The atmosphere becomes charged with a noticeable edifi-cation and inspiration.

This type of gift is described in 1 Corinthians 14:27-28: "If any man *speak* [The fuller Greek word for

51

"speak" here is: "laleō" which means "to preach".] in an unknown tongue, let it be by two, or at the most by three, and that by course; and let one interpret. But if there be no interpreter, let him keep silence in the church; and let him speak to himself, and to God."

Ministerial tongues should therefore not come forth if there is not someone present that has the gift of the interpretation of tongues. Otherwise it causes confusion in the church setting. The Scripture we just read also teaches us a basic rule. There should only be two or three messages in ministerial tongues in a given setting. From what I have studied about New Testament times, there were some churches that used up most of the service speaking in tongues and interpreting, when the Highest order of *every service* should be the Word of God. God confirms *His Word* with signs following. (Mark 16:20)

The Gift Of Interpretation Of Tongues

So if you speak in an unknown tongue, pray that you may interpret. (1 Corinthians 14:13) This verse clearly refers to the gift of ministerial tongues and the gift of interpretation. When both of these gifts are in operation, someone will give a message to the church audibly out loud and then the interpretation of that tongue will be given audibly and out loud.

In a church setting, the Holy Spirit will speak to a person that has the gift of ministerial tongues. The Holy Spirit will deal with the leaders in that church setting to get quiet, because they perceive that the Holy Spirit has a message for the church. As it gets quiet, the

person with the gift of ministerial tongues will raise his or her voice so the whole congregation can hear him or her speak. After this happens, someone that has the divine gift of interpretation will then raise his or her voice in the natural language of that church and give the interpretation of the tongues just spoken.

A really good example of the gift of interpretation of tongues took place when I was in Japan doing some miracle services back many years ago, in approximately 2005. This is the first and only time I have ever experienced this. In the church setting, the people were worshiping and praising God, and then it got quiet and all of a sudden this Japanese lady gave a message in tongues in English. It was really beautiful, something about worshiping God and honoring God. I thought the lady was being used of God with the gift of prophecy. It sounded like she had the most excellent English I've ever heard. Then a few moments later someone across the auditorium stood up and spoke in Japanese. At first I was a little confused. I didn't know what was going on because I do not speak Japanese. I can speak a few things in Japanese but not enough to know what was going on.

After the service I went to that lady that gave the first message in English, and I said, "You really speak beautiful English!" That's when I found out: she couldn't speak a word of English! Not one word!! There are diversities of tongues. The Scriptures teach us that if there is the gift of ministerial tongues and then the interpretation of that tongue and/or the gift of prophecy being manifested, it is for the church to receive edification.

The gift of ministerial tongues then is another type of tongue. Most people do not have this gift in operation in their life on a regular basis. This is really an office. If a person has the office of ministerial tongues, they will use them quite often so that the church will be edified. But as I said earlier, God has given to all of us all nine gifts of the Holy Spirit. We all have the gift of ministerial tongues, but we may only use it once in a lifetime, or maybe once every few years. If there is no one in a church service that has the gift of ministerial tongues, but God wants this gift to be in operation because He has a special message for the church, a person that is filled with the Holy Spirit with the evidence of speaking in tongues will sense that God is wanting to speak to the church, so they will yield to that gift.

The Gift Of Tongues For A Witness

"Wherefore tongues are for *a sign*, not to them that believe, but to them that believe not: but prophesying serveth not for them that believe not, but for them which believe." (1 Corinthians 14:22) Note, the italicized phrase is the Greek word, "semeion" which in the Greek means, "miracle, wonder, by which a person is distinguished from others. An unusual occurrence, transcending the common course of nature of signs portending remarkable events soon to happen of miracles and wonders by which God authenticates the men sent by him, or by which men prove that the cause they are pleading is God's."

When people speak in tongues, there is an undeniable supernatural, divine atmosphere that is manifested. This causes the non-Christian to know supernatu-

rally that God is real and that God is right there in their presence. This world needs the divine, supernatural manifestations of God to help them believe in God.

The Gift Of Prophecy

1 Corinthians 14:5 tells us: "I would that ye all spake with tongues, but rather that ye prophesied: for greater is he that prophesieth than he that speaketh with tongues, except he interpret, that the church may receive edifying." I want to clarify this passage in reference to speaking in tongues. As you study the Book of 1 Corinthians, you will find that it was written to the church at Corinth. (See 1 Corinthians 1:2) The Apostle Paul, by the inspiration of the Holy Spirit, was giving this church an order of service in the 14th chapter. He let the church know that in a church setting, it is better to prophesy than to speak in tongues, *except* there be someone that has the gift of interpretation. This passage, then, lets us know that ministerial tongues and the gift of interpretation are equal to the gift of prophecy.

God was not saying that we should focus only on prophecy and forget about speaking in tongues. There are too many verses in the Bible that speak about the importance of speaking in tongues. God is just letting us know that it is much better, *in a church setting,* for people to prophesy than for everyone to be speaking in tongues. When people speak in tongues with no one there to interpret, no one knows what is being said. However, when the gift of prophecy is in operation, a person raises their voice loud enough for everyone

present to hear, and they speak words of God for the whole church.

In 1 Corinthians 14:3, the Bible gives us clear understanding of the manifestation of the gift of prophecy: "But he that propesieth speaketh unto men to edification, and exhortation, and comfort." The Greek word "edification" is "oikodome" which has the fuller meaning of "house builder, build up, affection, grace, virtue, holiness". So when a prophecy goes forth that is God-inspired, it builds up the hearers and causes Godly grace, strength and holiness to be added to their lives.

The word "exhortation" in this passage is the Greek word "paraklesis" which has the fuller meaning of "consolation, a calling near, invite, encouragement, that which affords comfort or refreshment thus of the Messianic salvation (so Rabbis call the Messiah the consoler, the comforter)". When the gift of prophecy is in operation, words go forth that will draw people to the Lord, give them divine encouragement, and refresh them supernaturally. In this same verse, the word "comfort" is the Greek word "paramythia" which has the fuller meaning of "calming and consoling, consolation and encouragement". The gift of prophecy will then divinely, supernaturally build people up, draw them closer to the Lord and give them comfort spiritually.

God wants everyone that is born again and filled with the Holy Spirit to prophesy. There are several verses in 1 Corinthians, chapter 14, that validate this: "Follow after charity, and desire spiritual gifts, but rather that ye may prophesy." (vs. 1); "I would that ye

all spake with tongues, but rather that ye prophesied: for greater is he that prophesieth than he that speaketh with tongues, except he interpret, that the church may receive edifying." (vs. 5); "But if *all prophesy*, and there come in one that believeth not, or one unlearned, he is convinced of all, he is judged of all:" (vs. 24); "For ye may *all* prophesy one by one, that all may learn, and all may be comforted." (vs. 31); [Note: the word "may" used in this last passage is the Greek word "dynamai" which has the fuller meaning of, "be able, can, be of power".] "Wherefore, *brethren, covet to prophesy*, and forbid not to speak with tongues." (vs. 39).

By keeping things simple, we can understand clearly from the last five verses taken from 1 Corinthians, chapter 14, that it is a strong doctrine of God that every born again, Spirit-filled Christian that speaks in tongues, can and should prophesy on a regular basis. For more Scripture references that validate this truth, you need to read my book, *Mystery Of The Ages*. In it, I reference over 100 Scriptures from the New Testament that all can and should prophesy on a regular basis.

Many people confuse the gifts of the Holy Spirit with the offices of the Holy Spirit that have the same basic name. This causes people to shy away from the gifts because they know they do not have the office. A good example is the gift of prophecy versus the office of prophecy. The gift of prophecy is given to everyone that is born again and Spirit-filled with the evidence of speaking in tongues.

The office of prophecy, on the other hand, is the office of a prophet. Not everyone that prophesies is a prophet. A person that prophesies has only a small

part of what a person with the office of a prophet has. A billionaire has billions of dollars. Just because a person has ten dollars doesn't make him or her a billionaire. They have a small part of what the billionaire has billions of. Many times people get into trouble because they have prophesied once or twice and now they think they are a prophet. Let's examine the office of a prophet so you can clearly understand the difference between the office of a prophet and the gift of prophecy.

The Office Of Prophecy

The office of prophecy, as I said earlier, may also be called the "office of a prophet". Let's examine from the Scriptures what the office of a prophet does, so we can see and understand the way it differs from the gift of prophecy. 1 Corinthians 12:28-29 makes it seem like only a prophet can prophesy. Notice what it says: "And God hath set some in the church, first apostles, secondarily prophets, thirdly teachers, after that miracles, then gifts of healings, helps, governments, diversities of tongues." (vs. 28) "Are all apostles? are all prophets? are all teachers? are all workers of miracles?" (vs. 29) And of course the answer to that is no. Not everyone is called to be a prophet. However, everyone that is born again and filled with the Holy Spirit can and should prophesy, as I brought out earlier.

If we study the rest of the Scriptures referred to here, we see that this passage is talking about the office of prophecy, which is the same thing as the office of a prophet. In this section of the book I'm going to differentiate between the gift of prophecy and the office

of prophecy. As I noted earlier in the section entitled *The Gift Of Prophecy*, 1 Corinthians 14 alone gives us five verses that teach us that we should *all* prophesy. Now let's see what the difference is between the gift of prophecy and the office of prophecy.

A prophet prophesies on a regular basis as well as operates in the gifts of revelation. The prophet uses the gift of prophecy as a channel for the revelation gifts to flow through. The gifts of utterance also operate strongly within the office of a prophet as the gift of prophecy is an utterance gift. While the gift of prophecy is audible it does not have any other gift manifested along with it. The prophet will have the gift of discerning of spirits operating as a primary manifestation in the office of a prophet. The gift of discerning of spirits allows the prophet to see, hear, smell, taste and feel in the spirit world. And that is why in the Old Testament the prophet is referred to quite often as a "seer", because they see into the spirit world. Notice 1 Samuel 9:9 speaks of this when it says: "(Beforetime in Israel, when a man went to enquire of God, thus he spake, Come, and let us go to the seer: for he that is now called a Prophet was beforetime called a Seer.)"

Let me say with all kindness, if a person has to go around boasting that they are a prophet, then they are not. The office demonstrates itself. If a person is always telling you they are happy, you can rest assured they are sad. I learned this truth when I was in the seventh grade. There was a boy that was in the eighth grade and he had failed a grade so he should have been in the ninth grade. Everyone knew he was a bully and all the boys were afraid of him. He pushed boys around

all the time and intimidated all of us. He was always telling all the boys how tough he was, and how he beat so many boys in fights. And he was much bigger than all of us because of his age. So all the boys were afraid of him.

At this time, I used to go to a Boys Club in St. Charles, Missouri and do some boxing. One day while I was in the ring, I turned around and saw the coach putting this bully in the ring with me. I told the coach I did not want to box this guy as he is the bully of the school. I'll never forget what the coach said to me. He looked at me and smiled and said, "Mel, I've seen you box and I've seen this boy box. I know you can whip him." Well that gave me a lot of confidence because I knew the coach was a credible person. We started the first round and the bully came strong towards me, swinging his arms like a windmill. I thought, "This guy doesn't know how to box at all!" I just stayed out of his way until he stopped swinging his arms all over the place and then danced right up to him and threw a right punch to his jaw and knocked him out cold.

I found out early on that if a person is broadcasting that they are something, then most likely they are not. If you are a good boxer, you do not have to tell people, it will show. In the same way, if you are a prophet, you don't need to tell people. You will be very humble about it, knowing it is a gift of God that you did not earn. It was simply given to you by God's grace to bless people and glorify God.

Now let me show you a difference between the gift of prophecy and the office of a prophet that's found in Acts 21: 9-11: "And the same man had four daughters,

virgins, which did prophesy. And as we tarried there many days, there came down from Judea a certain prophet, named Agabus. And when he was come unto us, he took Paul's girdle, and bound his own hands and feet, and said, Thus saith the Holy Ghost, So shall the Jews at Jerusalem bind the man that owneth this girdle, and shall deliver him into the hands of the Gentiles."

Notice that the four ladies prophesied to Paul and the others with him, but the writer of the Book of Acts did not label them as prophets. They were using the simple gift of prophecy to edify or build people up, draw them closer to God, and comfort them. But there was a distinction made when Agabus came. The Scriptures call Agabus a prophet and he was used by God to foretell the future. Nothing was said about the young ladies foretelling the future. Do you see the difference? Agabus did not operate with a simple gift of prophecy but he had the office of a prophet and foretold the future.

4

THE THREE POWER GIFTS

God is an unchanging God. He doesn't have anything but good for you. I want to now share with you about the three power gifts of the Holy Spirit. You will be blessed by the Word of God. The power gifts *do* something. The power gifts include: 1. The Gift of Healing; 2. The Gift of Working of Miracles; and 3. The Gift of Faith. Each of these three gifts also has an office. As we discussed earlier, not everybody can have the office, but everybody can have the gift. There is a difference.

The office is more amplified. It's used on a regular basis and it is something that you really desire. If you desire to be in that office or desire in your heart to be in that office, then you are called into that office. Any desires of God that are in your heart and spirit, if it's really in your spirit, will never leave. "For the gifts and calling of God are without repentance." (Romans 11:29) The Greek word for "repentance" in this verse is "ametamelētos" and is also rendered as "irrevocable". So if you have had a particular desire to operate in the gift of healing for several years, you can rest assured you are called to hold that office.

The true test of whether you are really called to hold the office of a pastor, for example, or not, is when after two or three years of pastoring it seems like so many things are not advancing the way you think they should. In fact, most things seem to be going pretty rough. Finances may be a struggle and you may have made a lot more money in the secular world. Or many of the people of the church you are pastoring may turn against you for some of the silliest things. You may have been a pastor for only three years and you already have had three splits in the church that caused one-fourth of the church to leave each time. Your children may not like your church and your relatives may treat you like an outcast. By the way, they would treat you better if you ran a bar. And on and on it goes.

But if, after all that, deep down inside of you, you have more contentment and more peace than you've ever had, then you are definitely called to the office of a pastor. You think, well things look bad, but my worst day as a pastor is better than my best day doing what I was doing before. Money, fame and all this world has to offer does not compare with being in God's perfect will. Success is doing what God asks you to do, not what the world calls success. I think of the apostle, Peter. God told him to go and preach to a large crowd of people in the open city of Judea and 3,000 people got saved. (See Acts 2) And again, God told His disciple, Philip, to walk 71 miles as the crow flies across a desert to Gaza to preach to only one man, and that one man got saved. (Acts 8:26-40) Who was more successful, Peter or Philip? They were both equally successful, because they both did what God asked them to do. It's

sad to say, but many people today still judge people by their circumstances rather than by what God says.

For many years, I can remember writing letters to every famous minister in the world and inviting them to come to our church to conduct a meeting. I did this for many, many years and none of them would come when they found out how small our church was. Many of those same ministers, however, would always find time to go to the large church that was about 15 miles from our church. Even when I asked years in advance, they were always booked. But they would always come to the large church down the road. Then one night I had a dream, and I saw Jesus, and He said, "Mel, I'll come to your church." And He did!

Donna and I have been pastoring full time since 1972 and most of the time it hasn't been easy. I have had to work two and three different jobs at a time, and not even good jobs sometimes, just to get by. I am not ignorant. I could do other things. I have a business mind. My younger sister is a lawyer and I could have easily been a lawyer. I could easily have been a surgeon. I have those capabilities. But I would be the worst surgeon on the face of the earth because my heart just isn't in it. I would rather do what God wants me to do and make nothing and have a rough time of it than to work at something and have all kinds of prosperity and seeming success, but inside I know it is not me. Again, if you have a desire for any of the offices, it will always be there, regardless of the circumstances. If, after all is said and done, you continue to have a joy, peace and contentment inside of you about what you are doing, then you are called to hold that gift or that office.

Not very long ago, I was talking to Kermit, one of our staff persons, who is an usher. Kermit drives a long way to come to my church and never misses a service. He drives about an hour one way. We had lunch together and while we were talking, I knew that Kermit was called into the office of healing. I don't know if he has an office to preach but it just burns in his heart to pray for others to be healed. And it has always been that way for him and a lot of people get healed when he prays for them. So that's an example of someone who is called to the office of the gift of healing. If you have that desire then you can have that office.

God has given everyone all the gifts of the Holy Spirit. He has given them to the whole human race. However, you have to be born again to understand that you have the gifts of the Holy Spirit. And if you are not filled with the Holy Spirit, with the evidence of speaking in tongues, then you will not be aware that you have the gifts, and they won't dwell inside of you. It's like having the Holy Spirit walk beside you. He has all the gifts and they belong to you. But only if you are filled with the Holy Spirit with the evidence of speaking in tongues, so that the Holy Spirit dwells inside of you, will you actually receive all the gifts. Otherwise, you'll have only Old Testament experiences which do not last. But we now have a new covenant established upon better promises and God wants us to have more.

As I brought out earlier in this book, by examining 1 Corinthians 12:1-11, *all* of the gifts of the Holy Spirit are given to the whole human race. They just need to receive them. By looking at the Greek word for "another" in these passages of Scripture, you find

that it is also rendered "to one another" and where it is rendered "For to one..." (1 Corinthians 12:8), the Greek also renders that phrase as "in fact, indeed". These truths coincide with the rest of the Bible. They do not contradict the Bible. So again, we have all of the gifts of the Holy Spirit given to us. Just remember, if you are filled with the Holy Spirit, with the evidence of speaking in tongues, you will be much more proficient in the operation of the gifts of the Holy Spirit.

Let's look at that last statement this way: if a person was given a Rolls Royce automobile that would be great, wouldn't it? A Rolls Royce automobile is a nice automobile and has many features that would be a blessing to its owner. However, even if the car was gifted to someone, if that person is blind then it does them no good. They cannot drive the car and if they did try and drive it, they would have a wreck. In the same way, when you are filled with the Holy Spirit, you begin to see clearly the gifts that have been given to you and you are able to flow in the gifts of the Holy Spirit much easier.

The Gift Of Healing

We have validated the fact that the gifts of healing are for everyone. Really the phrase rendered *gifts of healing* in 1 Corinthians 12:30, is more accurately rendered as *offices of healing*, because all the other gifts listed in 1 Corinthians 12:28-30 are referring to offices. Apostle is an office. Prophet is an office. Evangelist is an office. Teacher is an office. Governments is an office. (See Ephesians 4:11) And so there is an office of heal-

ing. The office of healing is more magnified than the gift of healing.

Healing is a process. In the Book of Matthew, chapter 9, verse 22, we see that Jesus prayed for a lady that had an issue of blood for 12 years and she was healed. "...Jesus turned him about, and when he saw her, he said, Daughter, be of good comfort; thy faith hath made thee whole. And the woman was made whole from that hour." The woman received her healing from Jesus but He never really prayed for her at all. An anointing flowed out from Jesus' life and into hers and healed her because of her faith. Real Bible faith has actions. This woman had actions of trust, confidence and faith and it caused her to reach out and touch the hem of the Lord's garment as He was passing by. Immediately the anointing of healing began to flow from Jesus into her body.

Notice that the Bible says she was made whole from that *hour*. That word "hour" is the Greek word " hora" which is also rendered as: "day, season, (even-)tide, (high)time". It means she was made whole or healed by eventide, evening, or at that season. We would refer to what Jesus made happen as a healing, not a miracle. A miracle is instant. She could have been healed over several hours of time or over a season of time. We really don't know. When we get to Heaven we can ask Jesus, but according to the Greek it could have taken as long as one whole season for the woman to be healed. A season is three months. But it does say she began to amend from that very hour.

Oftentimes as we read the Bible, we see that Jesus would pray for people and what they actually received

was a healing, not a miracle. They began to amend. But if you have cancer and the doctor says you are going to die in three months, but instead you are fully free from cancer in three months, that's alright, isn't it? You just get a little better every day. That is the gift of healing. Sometimes the reason people do not get a miracle is that they would forget God if they received a miracle. When a person is being healed, every day they learn to trust God. It's like going to school. It may take you a while to be healed, but by the end of that time period, you will have learned to walk really close to God.

For a lot of people, if they received an instantaneous healing or a miracle, they would leave the church and never learn to trust in God. Many years ago, probably 20 to 25 years ago now, one such lady who attended my church did just that. She received a documented miracle. It was even written up in the newspapers. Sid Roth had me on his program to talk about this lady. We had all the documentation about this particular lady and I forget all the things that were wrong with her, but one of her legs was shorter than the other, she had scoliosis of the spine and knots the size of a golf ball up and down her back, as well as several other things wrong with her. She came to our church to be prayed for and got healed instantly. It was a miracle. Her spinal column straightened up, all the knots on the bones of her back disappeared and she stood up straight. She was so excited. She had no pain for the first time in many years. She danced all over the place and shouted. It was wonderful what God had done.

Well, there was a lady that came to our church that had brought the lady who was in pain, because the

lady in pain worked for her. She was her boss. After the lady who received the miracle had danced around a while, she ran back into the bathroom and had this other lady, her boss, go with her. She said, "Please come with me. I have a problem here. I can't find my colostomy bag." She needed the colostomy bag because her colon didn't work properly. She said, "I can't find it." She was really upset. She was sure that when dancing around she must have dropped it or something and she said, "I am going to have a mess." All of her bodily wastes went into the colostomy bag. Ten years prior to this time, she had to have a colostomy bag attached to her because her rectum had actually been sewn up.

She went back to the restroom with her boss to check for the colostomy bag and I continued praying for other people, when all of the sudden they came out and they were both shouting because the bag had disappeared and her rectum had been opened up immediately! They said she had the imprints on her side where the colostomy bag used to be but the bag had vanished and her rectum had supernaturally opened up. It was a bonafide miracle.

But here is the sad part of the story. She came to church the following Sunday. She was excited. She had gone to the doctor and the miracle had all been documented. And then the following week she wasn't at church. I asked her boss where she was and she acted really sad about the whole situation. She said, "I don't know. She robbed me and then left town." So the lady that received the miracle would have been better off just getting a healing that continued to manifest over time. So some people do not get a miracle because they

need to trust God. They need to build a relationship with God. Again, healing is a process and miracles are instant.

In Luke 17:11-14, we see another example of Jesus operating in the gift of healing in His ministry. "And it came to pass, as he went to Jerusalem, that he passed through the midst of Samaria and Galilee. And as he entered into a certain village, there met him ten men that were lepers, which stood afar off: And they lifted up their voices, and said, Jesus, Master, have mercy on us. And when he saw them, he said unto them, Go shew yourselves unto the priests. And it came to pass, that, *as they went, they were cleansed."*

I want to point out here that the gift of healing is no less a miracle than an instantaneous miracle. Jesus was God in the flesh. (See John 1:10; John 1:14) God knows what is best. All ten of these men received the gift of healing, which is a process, not the gift of a miracle, which is an instant manifestation of healing. They were all healed as they went. It could have taken them a month or more to be healed, as in those days, by law, if you were ever cleansed of leprosy you had to go show yourself to the high priest. The high priest may have lived many miles from where the lepers were. Some or all of them may have had limbs (feet) missing. We do not know the degree of leprosy each one of them had. All we do know is that *they were healed as they went.* That is the gift of healing.

The Gift Of Working Of Miracles

The next gift we are going to look at is the gift of

working of miracles. In the King James Version of the Bible, 1 Corinthians 12:10 speaks of how, "To another the working of miracles..." is given. The Greek rendition of that verse is actually the proper rendition as it is in agreement with what the majority of the Bible says. In the Greek, that same verse is translated as, "To *one another* is given the working of miracles...", not just "*To another...*", as the King James says. We have all been given the gift of working of miracles.

Jesus said, "...the works that I do shall he [you] do also; and greater works than these shall he [you] do...". (John 14:12) What did Jesus do? He did a lot of miracles. So we can see from this that we all have the gift of working of miracles. 1 John 4:17 says, "...as he is, so are we in this world." In other words, we can do what Jesus did. 1 Corinthians 6:17 tells us: "...he that is joined unto the Lord is one spirit." If you are one with Jesus, you can do what He did. There are many Scriptures that show us we can do the same things Jesus did. That is the gift. We can all have that.

Many times, we see in the Bible, people that were prayed for received a miracle. In Acts, chapter 3, Peter was at the gate called Beautiful and there was a man laid there who had been lame from his mother's womb. Peter prayed for the man and the Bible says that he was immediately healed. I am inclined to believe that it was Luke that wrote the Book of Acts because Luke was a doctor and he used terminology that a doctor would use in his writings. In Acts 3:7, it says of the man that received the miracle, that "... immediately his feet and ankle bones received strength." If it would have been Matthew, who was a tax collector, writing about the

incident, he would have just said that the man was healed. That is a miracle. That is the gift of working of miracles in operation.

But, you may ask, what about 1 Corinthians 12:29? "...are all workers of miracles?" The answer is absolutely not. It may, at times, look like the Bible is contradicting itself but it is not. That particular Scripture is referring to the *office* of the working of miracles and not the *gift* of working of miracles. One is a gift and the other is an office. If you have the office of the working of miracles, you operate in the working of miracles on a more frequent basis.

I once gave a natural illustration of the difference between an office and a gift of the Holy Spirit in the church that I now pastor. We have a female doctor that attends our church and if anyone is pregnant and ready to have a baby, she can take care of you. She is proficient at delivering babies. You don't want me to do that. I could probably do it, if I had to, because I have delivered baby calves before, but it's not the same. She can do a much better job than I can because she is a professional.

When I was illustrating this point, I asked the doctor if she could do, say, some minor plumbing repair work if she had to. She shared that she could do a little plumbing work at her house if need be, but she is not proficient at making plumbing repairs. That's not her calling. She doesn't like to do plumbing work and she doesn't want to do plumbing work. But she delivers babies every day. Day and night she is on call. So if some lady says it is her time, she's out the door and on her way to help. She loves her job. She loves it because

73

that is her calling in life. So we could say she has the office of delivering babies. But when it comes to performing some minor plumbing repairs she has just a small gift to do that type of work. She is not a plumber and that is not her area of expertise.

My point is, we all have the gift of working of miracles and if something happens to where the gift of working of miracles needs to be in operation, you can do that, but if you have that office, you do it all the time. You love doing it. It is your calling and you are an expert at it.

The Apostle Paul speaks in 2 Corinthians 12:12 of the office of miracles being wrought in his ministry when he says, "Truly the signs of an apostle were wrought among you in all patience, in signs, and wonders, and mighty deeds. " Miracles were in the Apostle Paul's life on a consistent basis. The word signs refers to supernatural miracles in the sense realm proving that Jesus Christ is Lord. The word wonders refers to supernatural miracles in the imagination realm proving that Jesus Christ is Lord.

Signs and wonders are the manifestation of the gift of working of miracles. The Bible is full of examples where the gift of working of miracles are in operation. Let's look at a few. In Exodus 14:13-22, we read the account of Moses flowing in the gift of working of miracles when he stretched forth the rod that was in his hand and the Red Sea opened up. The Red Sea is about 1,700 feet deep and it not only parted but the floor of the sea became dry ground so that the children of Israel could walk through it and escape the Egyptian soldiers that were out to kill them.

An astonishing miracle is found in Numbers 22:23-31. It tells the story of God's miracle working power opening the mouth of a donkey so that it spoke to Balaam, a prophet, who was acting in direct disobedience to God's commands. The talking donkey kept Balaam from being killed.

In Joshua 10:12-14, the children of Israel were in trouble while fighting against their enemies to enter into the promised land. Joshua spoke to the sun and the moon to stand still so that the children of Israel would have the victory and defeat their enemies. The Bible says in verses 13 and 14 that God hearkened to the voice of a man and the sun and the moon stood still for almost one whole day.

In the New Testament, in Matthew 9:24-25, we read the account of a maid who was dead. The Scriptures say the Jewish people laughed Jesus to scorn when He spoke of the maid being simply asleep and not dead. Jesus ignored their remarks. He put the people out, took the maid by the hand, and raised her from the dead.

In Matthew 9:27-30, there were two blind men following Jesus and crying out to Him to be healed. Jesus touched their eyes and immediately their eyes were opened. That is a miracle.

Another type of miracle, the miracle of multiplication, is recorded in Matthew 14:13-21. Jesus prayed over a little boy's lunch consisting of five loaves of bread and two small fishes. And from that little boy's lunch 5,000 people were fed. Notice in verse 20 it says that not only were all the people fed and filled but 12

baskets of remaining fragments were gathered up as well.

This reminds me of a time when Donna and I were pastoring a church that was prejudiced against Mexican and black people. In those years I did not advertise that I had strong American Indian blood and black blood in me. I could get away with it because I have other blood in me as well. At this particular church, however, if they had known that I had some black and Indian blood in me, they would never have asked me to come and be their pastor. In that town, one-third of the people were black, one-third of the people were Mexican, and one-third of the people were white. Donna and I visited and loved everybody, blacks, whites, Mexicans, everybody.

In this town, way back then, black and Mexican people were not welcome in white churches, so when I began to invite black and Mexican people to attend church, they were more than happy to come. They filled the church. The only problem was that the church I was pastoring was run by a demon board. I mean deacon board. You get the message. And this deacon board came to me and told me that they did not want black and Mexican people in their church. I explained to them that we must learn to love all people on earth because we will all spend eternity together in Heaven. Well, the chairman of that board got real close to me and said in a very surprised voice, "You mean you do not know?" I said, "Know what?" Now here is where demonic traditions can make a person extremely stupid. He said "We are not all going to the same Heaven. There is a Heaven for blacks and a Heaven for Mexi-

cans." I asked him where in the world he ever got that idea and he said it is in the Bible somewhere. I knew then that I was up against a demon and you can't reason with a demon.

I told this board that I was not going to tell the black and Mexican people to leave and I was not going to stop inviting them to church either. The chairman of the board said, "We will see about that." Those kind of churches have a system they use to get rid of pastors that they do not want. They stop giving them any money. And that is exactly what they did. Donna and I and our two daughters had no money to live on for food or anything else. The deacon board told me that I had to leave, but I told them I would not leave because God did not tell me to.

It was absolutely supernatural how God met our needs. One experience that I will never forget, was when I needed to drive over to some people's house. I knew I had very little gas in my car and no money. I got in my car and started it up and looked at the gas gauge and it was on empty. I said in my heart, "God I am working for You so it's up to You to take care of me and my family as we work for You." I began driving down the highway when I noticed my gas gauge moving. I watched as the needle went from below empty to three-fourths of a tank of gas. God supernaturally provided gas for me when I needed it. I drove a long time on that three quarters of a tank of gas. God is a miracle working God. He is our source, not people.

Because I was trusting God, the gift of working of miracles began to operate. I really didn't know how God was going to fill my gas tank. I did not say any-

thing about it to anyone. If I have a problem, I do not speak it out loud, so the devil and demons can take advantage of the situation. I assumed that God would speak to someone to give me some money but He had other plans and provided gas for me through means of a miracle.

In Matthew 14:24-29, Jesus came walking on the sea to his disciples who were in a boat out in the midst of the sea. The disciples were afraid but then Peter asked Jesus if he could walk on the water also. Jesus said only one Word to Peter, "...Come..." (vs. 29), and with that one Word, Peter got down out of the boat and began walking on the water like Jesus did.

In Matthew 15:30-38 is the account of 4,000 men, not counting women and children, that followed Jesus out of the city. Jesus prayed for them all. In verses 30 and 31 of Matthew 15, it speaks of Jesus making the maimed whole. The word "maimed" in the Greek is the word "kyllos" which is rendered as "mutilated (dismembered)". Clearly certain individuals were missing body parts. All of the people missing body parts were made whole! That is a miracle.

In Mark 3:1-5, we see another story of a man that had a withered hand. The Greek word for "withered" is "xērainō" and has also the meaning of, "to shrivel, dry up, shrunken". Jesus operated in the gift of working of miracles and caused this man's hand to be instantly recreated whole as his other hand.

In Mark 7:32-35, one was brought to Jesus who was deaf and mute, and Jesus prayed for him, and this passage says "...straightway..." he began to hear and

speak. (vs. 35) The Greek word for "straightway" is "eutheos" which is also rendered as "immediately".

John 11 records the miracle of Lazarus being raised from the dead. He had been dead and embalmed for four days. I found out, through research, that when a person in those days was embalmed, a man weighing about 175 pounds would end up weighing over 300 pounds due to the embalming process. So for Lazarus to walk was as great a miracle as for him to be raised from the dead. The gift of working of miracles accomplished both at the same time. Lazarus was raised from the dead and walked out of the grave at the same time.

Now here is the good part: Jesus Christ and His power is the same yesterday, today, and forever. (Hebrews 13:8) The Bible promises that the works that Jesus did, you shall do also, and even greater works! (John 14:12-14)

In my book, *Neglecting Signs And Wonders Is Neglecting The Rapture*, I clearly validate that God not only has given you that power, but He is waiting on you to flow with all the gifts of the Holy Spirit to bring the masses into the Kingdom of God, which will then set the stage for the rapture of the church.

The Gift Of Faith

Now let's look at 1 Corinthians, chapter 12, at the gift of faith. The King James Version of 1 Corinthians 12:9 declares: "To another faith by the same Spirit..." is given. The Greek translation more accurately interprets that phrase as: "To *one another* faith [is given] by the same Spirit...". As we study the Bible we note that

there are three different types of faith. The first type of faith is the faith that all Christians can have simply by reading the Bible. We read in Romans 10:17 that "... faith cometh by hearing, and hearing by the word of God." That word "hearing" in the Greek is co-equally rendered as "giving audience to". So you are getting faith by hearing others speak the Word of God and by reading the Word of God for yourself. That's how you get faith. Everybody can have that kind of faith.

Secondly, then, there is a gift of faith that is given. This is more supernatural. When this gift is in operation, a person supernaturally trusts and has confidence in God and His Word. And thirdly, there is the office of faith. A person that has the office of faith trusts God and His Word supernaturally on a regular basis.

We see the gift of faith operating in Mark 11:12-14. Jesus talks to a tree and commands that tree to die... and it does. As we study God's Word, we see that Jesus was not cruel and just going around trying to kill trees. The problem was that the tree in question wasn't a proper tree. The Bible says Jesus cursed it by its roots and the tree dried up. That was the gift of faith in operation.

When the apostles came back by, they were astonished to see the tree that Jesus had cursed dried up from its roots. Jesus then tells them, in essence, you can do the same thing. In Mark 11:22, Jesus reveals to them that all you need is faith in God to do what He did.

I like what the A.S. Worrell translation says about Mark 11:22. Dr. P.C. Nelson was the founder of Southwestern Bible School in Enid, Oklahoma, in 1927, and

was a noted linguist. He was ranked as the number one authority in his day of the Greek language and the second-ranked authority of the Hebrew language. He could also read and write 32 languages. Brother Kenneth E. Hagin, Sr. made the statement that he had heard that Dr. P.C. Nelson once said that he considered the A.S. Worrell translation of the New Testament the closest to the original Greek of any version of the New Testament he had ever read.

In the A.S. Worrell Version of the New Testament, Mark 11:22 is translated as: "And Jesus answering saith unto them, Have the faith of God." God is telling us we can have the same faith that He (God) has! This is talking about the supernatural gift of faith that is available to everyone. Again, you will be at least 99.99% more proficient in receiving this gift and operating with it if you are born again and filled with the Holy Spirit with the evidence of speaking in tongues. God is not withholding it or any of His blessings from anyone. But if you are blind you cannot see what belongs to you. If you receive this type of faith you can talk to trees and they have to obey you. Wow! That means we can talk to things and they have to obey us. Jesus said that is how you do it.

The A.S. Worrell, not the King James, Version, says all you have to have is faith in God. But he also made it clear that what you need is the God kind of faith. You need the same faith that God has. When you have God's faith, you can talk to trees, you can talk to your car, you can talk to your wallet, you can talk to bodies and on and on, and things have to obey you. Now that's if you have the faith that God has.

Well, that's wonderful for God to tell us such things and it is real easy to say that. It's easy to say that! But how do I get the God kind of faith? It's real simple. The answer is found in the next verse, Mark 11:23. Jesus starts off by saying, "For verily I say unto you, That whosoever shall say...". He gives the instruction on how to have the same faith that God has. Faith, as we study the Bible, means trust, belief and confidence in God. It will cause you to have daring boldness. That's what faith is all about. The instructions to having God's kind of faith are found in verse 23. So if you want to have the God kind of faith, do what the instructions say. Mark 11:23 says, "...whosoever shall *say* unto this mountain, Be thou removed, and be thou cast into the sea; and shall not doubt in his heart, but shall *believe* that those things which he *saith* shall come to pass; he shall have whatsoever he *saith*."

The late Brother Kenneth E. Hagin, Sr., many years ago, said Jesus woke him up in the middle of the night and told him to come into the kitchen because He wanted to teach him some things about Mark 11:23 and 24. Jesus spoke to him and told him that if you want to have the God kind of faith you have to *say* something three times more than you believe it. If you notice, in that particular verse, Mark 11:23, Jesus speaks of *saying* something that you desire three times and *believe* only one time.

In other words, it is real simple to say I believe something, but if you keep saying it and keep saying it, what happens is, you build up your faith and you begin to believe what you are saying. That's why the Bible has so much to say about speaking the Word of

God. Keep speaking the Word of God. That's simple faith. The gift of faith will then grow in your life. The gift of faith is for everybody. Jesus tells us to have the God kind of faith. (Mark 11:22)

That's how my wife, Donna, and I stay healthy. We don't take any medicine whatsoever. If we needed it, we would take some. But if you don't need any, why take it? I am now 65 years of age. I haven't taken an aspirin since I was 27 years of age. If I needed one, I would take one. Now I am not saying that I don't get a temptation to get a headache. But when it comes I just tell the devil, in Jesus' name, you are not welcome here. Leave in Jesus' name. And it leaves. That's how we live and that's how we are blessed financially also.

There was a time that we went around and said for years, "we believe". At the time, we didn't have enough money to buy even our clothes. We bought our clothes at the Goodwill. I still have some Goodwill clothes. I take care of my clothes. But we went around for years saying, for example, "We believe we have a brand new house and it is bought and paid for in Jesus' name." And we just kept saying it for years. Now my wife and I have a house that is bought and paid for in Jesus' name. In fact, we got our house paid for back when I was about 39 or 40 years old. But for years we didn't have anything. We had nothing. We didn't have money to hardly feed our kids. But we spoke the Word of God. We kept speaking it and kept speaking it.

That's how our church building got built. We used to meet in a storefront in Wentzville, Missouri. To build the building that our church is currently in cost a lot of money but we did it by faith. That was in the office

of faith. That's how we built our ministry. That's how we built our church totally debt-free. We don't owe a penny to anybody personally or ministerially. That's how we conduct our television ministry. It's called operating in the office of faith because it is to bless others, not just ourselves.

1 Corinthians 12 does not mention the office of faith outright, but it does ask the question: "Are all apostles?...". (vs. 29) An apostle functions strongly in the office of faith on a consistent basis. I am not saying you have to be an apostle to have the office of faith but I am saying the apostle does have that office.

You may have and operate in the office of faith as a businessman or businesswoman. You may know how to believe God for great things to come to pass. That's just one facet of the office of faith. The office is for many people to be blessed, not just for you. Donna and I have operated in the office of faith for years. We went around saying that we believed our church building was paid for in Jesus' name. I can remember when we first moved into our current building and left the storefront. The payments at that time back in 1985 were like $3,400.00 a month. That's still a lot of money today. But that was a whole lot of money back then. There were times when our church was as much as $80,000.00 in debt. But we just kept speaking the Word of God and speaking the Word of God. We believed what God's Word said.

God calls those things that be not as though they are. (Romans 4:17) For years we believed for a television ministry. I knew that God had called me not just to pastor a church. I would be an absolute failure if

our church ran 100,000 people every Sunday morning. Even if it ran a million every Sunday morning, and that's all I ever did, I would be an absolute failure in God's eyes because that's not my major calling. My calling is to be a pastor but my major calling is to touch the world with God's love.

We are currently on the internet (CTN and GEB America) and on three Christian television stations on the Dish Network, DirectTV Network, Glorystar and ATT U-Verse (CTN, GEB America and FETV). For years we spoke and believed. That was the office of faith. When we started into the television ministry, there is no way we had the money to buy even one camera. Now we have four high definition cameras. We didn't have that kind of money. Ted, who works at our church in the television ministry, walks close to me and he has learned how to buy without money. We have a teaching about that dealing with Isaiah, chapter 55, how you can buy without money. And it works. That is the office of faith.

Faith works by patience. (James 1:3) As you study it out, you see that faith and patience are like twins. Wherever one is, the other one is. You can have all the promises of God with faith and patience. (Hebrews 6:12) Real Bible faith has patience with it. Patience says, "I've got it now."

There have been times in my life when I have been in third world countries and caught diseases where I was quarantined at home. I had a disease that medical science said if I ever got real close to people they would die. Now, though, I am fine because of faith, trust and confidence in God's Word. I did not die and no one

around me has ever died. That was several years ago. But you know what I had to do? I had to operate in patience with the gift of faith. I was not moved by what I felt, what I saw or what the doctors had said. I was only moved by something that is real. That is the Word of God! Now medical science can't find any form of that disease in my body. That's the gift of faith in operation. We are blessed by the gift of faith. Faith and patience go hand in hand.

There is a secret to having the gift of faith. Don't check with your eyes to see if something is still there and then say, for example, "Well, I guess I am not healed because I can still see it." When you do that, you are using the wrong eyes. The last word in 2 Corinthians 4:17 is glory: "…our light affliction, which is but for a moment, worketh for us a far more exceeding and eternal weight of glory;". And that word "glory" in the Greek is a word that means the "reputation of God". It is saying, in essence, that we have the reputation of God. God says that we have His reputation.

In 2 Corinthians, chapter 4, the entire chapter talks about God's reputation. It is already ours in our mortal body. We have it. God has given it to us. 2 Corinthians 4:17 says we have it. Here is the way God's reputation in us is activated. It says in 2 Corinthians 4:18: "While we look not at the things which are seen, but at the things which are not seen: for the things which are seen are temporal; but the things which are not seen are eternal." You use your spiritual eyes and look at those things that are not seen. So anytime somebody wants you to validate what you are believing for, just show them what the Word of God has to say. "*Now*

faith is..." Hebrews 11:1 tells us. That's the gift of faith and we all ought to operate in that. Again, the office of faith is just more amplified and is for other people.

Just recently God gave me an instruction, a mandate from Him, and I am pursuing it heavily daily in the Spirit. It is something that will cost our ministry a lot of money, not me personally. I couldn't believe for this for myself. That's the difference. It is for the world. And it will cost 45 to 50 million dollars. Well, I am about 50 million dollars short according to the natural. But you know something? I've got it. I am not going to get it. I have already got it. In fact, I already wrote a check. I wrote a check out to Agape Church in Wentzville, Missouri for 50 million dollars. It is sitting on my desk at home. That's the office of faith.

If I said I wanted to buy a Rolls Royce which costs something like $300,000.00 for myself, I couldn't believe God for a Rolls Royce. I don't even want a Rolls Royce. But even though I can't believe for anything for Donna and I personally that costs like $100,000.00 or thereabouts in the next year, I have a total tranquil peace about the millions of dollars God has shown me He wants to use for ministry purposes. The money God has me believing for is not to be used for personal means or gains.

I know that I know that I know that I already have this money and what this money is going to do in just a few months after I receive it. I am already working on it. I'm preparing for it. I'm making steps towards it.

Let me share with you another secret about the office of faith. When you have something that you are be-

lieving God for, don't tell people unless you are 100% positive that they can be in agreement with you. People can damage your dream or vision with their doubt and unbelief. The Bible talks about how two must be in agreement if they are to walk together. (Amos 3:3) Amen.

5

THE THREE REVELATION GIFTS

God is a good God and only has good things for you. In this particular chapter, I will be teaching about the three revelation gifts. 1 Corinthians, chapter 12, verses seven through ten, talks about all nine gifts of the Holy Spirit. But we are going to focus in this chapter on the three revelation gifts. The three revelation gifts *reveal* something, and they belong to all of us. The three revelation gifts are: 1. The Gift of the Word of Wisdom; 2. The Gift of the Word of Knowledge; and 3. The Gift of Discerning of Spirits.

The Gift Of The Word Of Wisdom

The first revelation gift we will be discussing is the gift of the word of wisdom. 1 Corinthians 12:8 declares: "*For to one* is given by the Spirit the word of wisdom; to another the word of knowledge by the same Spirit;". Notice the word in italics "For" is the Greek word "gar" which is translated as "indeed, no doubt". The italicized phrase "to one", in the same verse, is the single Greek word "hos" which is also rendered

as "that, which, whereof". Given the fuller meaning of the italicized words, along with over 700 verses just in the New Testament that validate we have all nine gifts of the Holy Spirit, a more accurate translation of that verse is as follows: "*Indeed whereof* is given by the Spirit the word of wisdom; to another the word of knowledge by the same Spirit;". The gift of the word of wisdom is very similar to the gift of the word of knowledge. The key difference is that the word of wisdom reveals supernatural, divine information from God concerning people, places, events or things relating to the *future*, whereas the gift of the word of knowledge reveals supernatural, divine information from God concerning people, places, events or things that relate to the *past* or *present*.

As we discussed earlier in this book, if you operate in the gift of the word of wisdom, you may occasionally use it. However, if you have the office of the word of wisdom, then it is more amplified and will operate all the time. If it is a desire of your heart and you are always looking for opportunities for God to be glorified and for people to be blessed by the gift, then you are operating in the office of the word of wisdom. This is true for all the gifts and offices.

God gives you the desires of your heart, so if you have a desire in your heart to flow in a particular gift or office, and that desire is there 24 hours a day and remains steadfast year after year, then you have the office of the Holy Spirit in that particular gift. "For the gifts and calling of God are without repentance." (Romans 11:29) This passage validates the fact that there is a difference between gifts and offices. The word "gifts"

in Romans 11:29 is a Greek word meaning "charisma" and the word "calling" in that same verse is a Greek word that means "vocation".

A vocation is an office. Romans 11:29 validates that there are gifts and there are callings or offices.

The word "repentance" in Romans 11:29 means to change one's mind. If God gives you the desire to have a particular office, then you will always have that desire, even if you never yield to it. God does not change.

1 Corinthians 12:7-10 talks about God giving to one another, or to everybody in the church, the various gifts, and that includes the gift of the word of wisdom. The gift of the word of wisdom is therefore given to everyone also. But 1 Corinthians 12:29 also asks the question, "...are all prophets?...", meaning do all have the office of the prophet that flows with the gift of the word of wisdom? Of course not. We are not all prophets or called to be prophets. Again, the difference is that the gifts are for everybody but offices are not.

We can see the word of wisdom in operation in the Old Testament. The Lord, in Isaiah 45:11, says, "...Ask me of things to come concerning my sons, and concerning the work of my hands command ye me." When God says that He will show us things to come, that's the word of wisdom in operation. God is telling the whole human race to ask for wisdom and understanding. It's a shame, but those who are not born again cannot hear the voice of God. This wonderful invitation is known only to them that are born again. It belongs also to those not born again, but they do not know it. For "...the natural man receiveth not the things of the

Spirit of God: for... they are spiritually discerned." (1 Corinthians 2:14)

You have to be born again to understand the Word of God. Once we are born again, we can then read and understand God's Word and know the wonderful things that belong to us. God says to call upon Him and He will show you things to come. (Jeremiah 33:3) Wow, isn't that wonderful? You can ask God and He will tell you of things to come. That's the gift of the word of wisdom. That's supernatural wisdom.

James 1:5 exhorts us to ask for wisdom. "If any of you lack wisdom, let him ask of God, that giveth to *all men* liberally... and it shall be given him." Here again, we see that the gift of the word of wisdom has been given to the whole human race. You can ask God, for example, "Should I invest in this?", and God will tell you.

As I study the Scriptures, I see that the three highest ways of God speaking to us are: Number 1: By His Word; Number 2: By dreams that are visions or vice versa; and Number 3: By witness or spiritual perception. God will always speak to us in perfect agreement with His Word. Each one of these avenues of God speaking to us is validated by at least three clear Scriptures from God's Word. (Matthew 18:16)

The way that God speaks to us by perception or witness is when we get a perception on the inside of us that a certain decision is either right or wrong. The voice of God can also be found in the desires of your heart when you delight in Him: "Delight thyself also in the Lord; and he shall give thee the desires of thine

heart." (Psalm 37:4) So then God may use the desires of your heart to speak to you also.

As you study the Word of God, you find that God will give you, "...the peace of God, which passeth all understanding...". (Philippians 4:7) It will be evident in your spirit, right in your belly. Some people may say, "Well, I don't know if I have peace." It's real simple. If you have a horrible cringe in your belly about something, then that is the opposite of peace. War and turmoil are the opposite of peace. The Holy Spirit will communicate to you in your spirit and the heart of your spirit is in your belly region. (See John 7:37-39) So, again, you can know the future by the peace that you have on the inside of you.

If you are filled with the Holy Spirit with the evidence of speaking in tongues, you will be much more in tune with the Holy Spirit communicating to you. If you are filled with the Holy Spirit, He will be in your belly. So, for example, if you get a thought or an intuition and on the inside you have an uneasiness about that thing, then that's the voice of God speaking to you... so don't do whatever that thing is. Many people disobey the witness on the inside of them and end up having problems.

Not long ago, in Colorado, some guy came into a movie theater with a gun and killed several people. On the news that night, a lady was interviewed that had been shot in the theater. She said that before the guy came in, she felt this horrible cringe on the inside of her. In other words, a horrible feeling that something bad was going to happen. Well, why didn't she just leave right then? She didn't. She stayed and was shot.

God was trying to tell her to get out. So, if you don't have a cringe inside of you about something, then you have peace. It's that simple. Everything that God does is simple. If it is not simple, then God is not involved in it. That is how you can know the perfect will of God concerning every area of your life.

Once you follow the leading of the Holy Ghost when He tells you to do something, that does not automatically mean everything will go wonderful in that situation for you. But if the Holy Spirit is telling you to do something, the way you know is, you will have peace on the inside of you, right in your belly region.

The Gift Of The Word Of Knowledge

Next, we will be discussing the gift of the word of knowledge. *"For to one* is given by the Spirit the word of wisdom; to another the word of knowledge by the same Spirit;"*. (1 Corinthians 12:8) Again, note that the italicized words used above "For to one" are taken from two different Greek words. The first word is "gar" which is also rendered as "indeed, no doubt", and the second word "hos" is rendered as "that, which, whereof". So the accurate translation of this verse is actually: *"Indeed whereof* is given by the Spirit the word of wisdom; to another the word of knowledge by the same Spirit;"*. Also note that the accurate translation I have just given is in agreement with the vast majority of the Bible.

If you read my book, *Mystery Of The Ages*, I refer to hundreds of verses that say the same thing I am saying

here. Namely, that the gifts have been given to all of us, not just to one or only a select few.

One such verse is 2 Peter 1:3, which says: "According as his divine power hath given unto us *all* things that pertain unto life and godliness, through the knowledge of him that hath called us to glory and virtue:". In other words, God has already given us everything that pertains to "Godlikeness". Since that is true, then God has given to us all nine gifts of the Holy Spirit. We just need to receive them. This verse also tells us that God has called us to glory. That word "glory" in the Greek refers to "doxa" which is accurately rendered as "reputation of God". If we have God's reputation, then we have all nine gifts of the Holy Spirit, including the gift of the word of knowledge.

One Old Testament passage that verifies that we each have the gift of the word of knowledge is Jeremiah 33:3: "Call unto me, and I will answer thee, and shew thee *great* and *mighty things,* which thou *knowest not.*" The italicized word "great" is the Hebrew word "gadowl", which translates as "important" or "God Himself". The italicized phrase "mighty things" is the single, Hebrew word "bâtsar" which is rendered as "secrets, mysteries, gold, precious ore". The italicized phrase "knowest not" is the single Hebrew word "yada", which means "knowledge, discovered, be wise".

What God is saying here is that the gift of the word of knowledge can be a reality in our life if we will simply call on the Lord. By calling on the Lord, He will give us knowledge, meaning secrets and mysteries of Himself. I want to draw your attention also to the word

"call" in Jeremiah 33:3. That same Hebrew word is rendered in the Old Testament many times as "read". In other words, God is telling us to read His Word. I have found that the highest order of praying is by reading God's Word. Jesus said "… I am the way, the truth, and the life: no man [person] cometh unto the Father, but by me." (John 14:6) The Bible declares that Jesus and the Word of God are synonymous, meaning they are one and the same. (John 1:1; John 1:14; Revelation 19:13) So no man cometh unto the Father but by the Word of God.

It is also important to note that Jeremiah 33:3 is found in the Old Testament. We now have a new covenant (New Testament) which is established upon better promises. (See Hebrews 8:6) So whatever God did for people in the Old Testament, He will surely do for us today, and even more!

God gives to us a fragment of His supernatural knowledge. He doesn't give us all of His knowledge, but just whatever is needed for a particular situation we may be dealing with.

One way to illustrate this is, for instance, if you go to a lawyer because you have a problem with a traffic violation. You would get the lawyer's counsel. However, the lawyer would only relay to you the specific information that deals with the traffic violation. He would not give you all the knowledge of his profession because that's not what you need. He only gives you a fragmentary part of his knowledge that applies to the traffic violation problem you are having.

And so it is with God. The Bible calls it a "word" of knowledge. God is drawing our attention to the fact that, just like a word is only a fragment of a sentence or paragraph, so God supernaturally gives you fragmentary knowledge for a particular situation you are dealing with. And the word of knowledge always has to do with things of the past or things of the present. By definition, the word of knowledge is supernatural information of the past and/or of the present given to us by God.

In a seminar that I did recently called *The Gifts of the Holy Spirit Seminar*, I demonstrated to those present the gift of the word of knowledge. Many of the gifts function together. I first spoke in tongues over a young man. Then I went to a second gift. I asked God for the interpretation. So that was the gift of interpretation in operation. The interpretation that the Lord gave me had both an element of a word of knowledge and a word of wisdom. Again, briefly, the word of wisdom is a fragmentary part of the vast wisdom of God concerning *future* events. The word of knowledge is a fragmentary part of the vast wisdom of God concerning *past* and/or *present* events.

The word that was imparted to me for a particular brother from Africa was that in the past he had really searched for God and longed for God to do some great things. This brother had traveled to and fro, throughout the world, trying to find God to do something for him and to take him to a higher level. So that displayed a third gift in operation, that of the word of knowledge which reveals your past and present. And then I spoke to him a word of wisdom, the fourth gift, which re-

veals the future. I told him, God says: "Wherever you are planted, bloom with the gifts of the Spirit and people will come from all over, the north, the south, the east and the west, to be set free and to be blessed by the Spirit of God, and all your needs will be met according to His riches in glory. Amen."

Any time a gift of the Spirit is in operation, you can be blessed by it also, even if words are not spoken directly to you or over you. If you are there listening and it blesses you, then you can receive it too!

We have had people in our service where the gift of the working of miracles was in operation and directed toward a particular person. But then, another lady in the service on the other side of the building had the exact same problem. She decided to take that word also, in case I didn't pray for her directly, and she received a miracle too! See, the anointing of God is for the taking.

This also works in the atmosphere of the gift of music and song. If it is blessing people, everyone in that place can accept the blessing from the music and songs that are being played and sung.

The Gift Of Discerning Of Spirits

The third revelation gift we are going to discuss is the gift of discerning of spirits. This gift is a wonderful gift and a great enhancement to your own life, as well as to other people you come in contact with. 1 Corinthians 12:10 mentions this gift: "...to another discerning of spirits...". As we discussed earlier, our modern day versions and translations read "to another" but the correct translation of that passage is actually "to one

another". The fuller meaning of this phrase is that to one another the gift of discerning of spirits is given.

1 Corinthians 12:29 asks if all are prophets but does not specifically mention the gift of discerning of spirits. But the gift of discerning of spirits functions all the time in the office of a prophet. It is part of the life of a prophet.

There have been times when people get into error thinking they are a prophet because the gift of prophecy operates at times in their life. They try to move into that office, when they are not called to be in that office, and end up backsliding as a result because it doesn't work for them. Just enjoy being who you are and doing what you enjoy doing. Don't try and be someone else. Be who you are.

The gift of discerning of spirits gives one the ability to see, hear, feel, smell and taste in the spirit world. But predominately it is to see. The word prophet in the original language of the Bible is often rendered as a gazer or a seer. They see in the spirit world. If you flow in the gift of discerning of spirits, you can occasionally see, or you may duplicate one or all of the five physical senses: seeing, hearing, smelling, tasting, touching. But a prophet does it all the time.

God has given all of humanity the gift of discerning of spirits. However, even if you are a born again, Spirit-filled Christian, if you don't realize that you have that gift, then you will not have the gift in operation in your life. Even a born again, Spirit-filled Christian that may know they have the gift, if they do not have knowledge

from the Bible on how that gift operates, will still not be able to operate in the gift of discerning of spirits.

In a book I have written called *Mystery Of The Ages*, I document many, many Scriptures that validate the fact that you have this gift. Also, if you go on the internet and type in your search engine, "How to See into the Spirit-World - Mel Bond - Youtube", you will get a two hour teaching that I have done on this gift. Most born again, Spirit-filled believers begin seeing in the spirit world after they see and listen to this teaching. Jesus said "And ye shall know the truth, and the truth shall make you free." (John 8:32) Back in 1973, I spent something like one whole week researching all nine gifts of the Holy Spirit. After I understood what the gifts of the Holy Spirit were and how they operated, I would say within a day or two, at least 80% of the gifts operated in my life. We can have whatever the Bible says we can have.

Years ago, I would have given a million dollars, if I would have had a million dollars, to get the understanding that I now have on this subject. This gift will greatly enrich your life. And you can get the information God has shown me free online. I give it to you free because I want you to function with the gifts of the Holy Spirit and get excited and win the lost so we can all go to Heaven.

Another Scripture passage that validates the fact that we have the gift of discerning of spirits is John 14:12. Jesus said that we can do the works that He did and even greater works. If Jesus was standing any place in the world, He could discern problems in each individual. If there was a demon affecting someone's

health, Jesus could easily see that demon spirit. Well, Jesus said we can do even greater things than He did, so we can also see into the spirit world, just like He can.

Philippians 2:5 says: "Let this mind be in you, which was also in Christ Jesus:". However, you will still have to allow the gift to operate through you. Don't make it difficult. Just let it flow!

We all use our spiritual eyes all of the time. Another word for using your spiritual eyes that helps us to understand the gift of discerning of spirits is "imagination". God has ordained from the very beginning of creation that humanity use their imagination. That's how we get around in this world. We see things in the spirit world first. We imagine things we are going to do before we do it or go there. In a CD teaching I did entitled, *Ordination Of Imagination*, I go into greater depth on this gift. God ordained us to use our imagination.

In Genesis 11:6, God speaks of some ungodly people, saying: "...Behold, the people is one, and they have all one language; and this they begin to do: and now nothing will be restrained from them, which they have imagined to do." God knew that the law or ordination of imagination had been discovered by this ungodly people and that He had to stop them because they would use it in an ungodly way. God said, not Moses, God said, "...*nothing* will be restrained from them, which they have imagined to do." How much more will it work for Godly people with Godly desires?

Electricity was designed to help the whole human race. If a born again Christian says he or she is not going to use electricity because someone involved in

the demonic teaching, New Age, uses electricity, that Christian would live in darkness without enjoying the laws and blessings of electricity.

Imagination has not been taught because some people are afraid of getting into false religions or doctrines. I am not afraid of that because I find many Scriptures to validate what I am doing and I plan on continuing doing it. I am not going to allow a false, religious sect to cheat me out of something that is pure, holy and Scriptural. 1 Corinthians 6:17 teaches us plainly, "...he [or she] that is joined unto the Lord is one spirit." In other words, we are one with Jesus. Jesus can easily look into the spirit world to bless people and honor God. Since we are one with Him, we then can do the same thing. You are His representative so you can do it also.

All people use their spirit eyes, you just don't realize it as such. Another way of saying that is, using your imagination or the gift of discerning of spirits. You can see an apple with your spiritual eyes or imagination any time you want to. You can see the color of the apple, the inside, what the seeds look like, etc. Everybody pretty much sees thousands of things in the spirit world with their imagination, their mind's eye, or their spiritual eyes, all the time. Any person can see what they want. So we just take that same truth and apply it to Scriptures. *See* what God has promised you in His Word.

If I come up to you and ask you to see in the unseen realm, you may say, "No, I can't. " I can then ask you to tell me what is in my pocket, and you would say, "I do not know." However, if I reach my hand inside my

pocket and pull out an ink pen and show it to you and you see that it is red, white and blue, you now have that information put into your mind. Now if I put the ink pen back in my pocket, where it is impossible for you to see it with your natural eyes, and I ask you to describe what the ink pen in my pocket looks like, you could describe it perfectly. You would do that based upon your mind's eye, which is your imagination, or your spirit eyes, and you would be perfectly correct. Natural knowledge was placed in your mind and that is the reason you could see with your mind's eye.

We can do the same things with Scriptural truths. What is more valid and more powerful: natural knowledge or supernatural knowledge, which is God's Word? Of course the answer to that is supernatural knowledge or God's Word. If we want to be blessed by God, we need to read God's Word and see it as truth with our spiritual eyes, our mind's eye, and imagination. God planned it that way so that the whole human race can be blessed. We make the things of God too difficult. If it is not simple, God is not involved in it.

God's Word tells us that demonic spirits or the kingdom of satan is of darkness. It's a dark kingdom. So if you look at a person, look for a dark image. If you see one, it is a demon spirit that is causing some kind of a problem. All people in the realm of the spirit are the same "color" and that color is "clear". We all look clear in the spirit world. The Bible says that we are all made in the likeness of God. We all look like God in the spiritual sense. We are all of the race of God.

In Habakkuk 3:4 we read: "And his brightness was as the light; he had horns coming out of his hand: and

there was the hiding of his power." I like the Amplified Bible rendering the best. It reads: "His brightness is like the sunlight; He has [bright] rays flashing from His hand, And there [in the sunlike splendor] is the hiding place of His power." Notice that God has sunlight splendor and rays of light streaming forth from His hands. Sunlight rays are warm and the sunlight splendor being talked about here is God's power. So when the rays of God's power touches you, it is warm, and it produces God's power when it touches a person.

God says, "...as he is, so are we in this world." (1 John 4:17) When we understand this truth, we know that we don't have to touch an individual for them to be healed and delivered and so on. Most of the people that I ask will say they feel a warmth. You can send a warmth. In the same way we can see and have whatever God's Word says we can have, we can also feel and have whatever God's Word says we can have.

Learn to use your imagination to manifest the gift of discerning of spirits based upon Habakkuk 3:4. With your imagination, see a beam of light come out of your hands just the same way in the natural you would see a flashlight beam in the dark. And, in the natural, if you were outside on a sunny day, you would feel the warmth of sunlight beams on your flesh. So now with your imagination (your spiritual mind) feel the warm sunlight splendor in the palm of your hands. You will notice that when you point this beam of sunlight splendor towards people and tell them of the warmth, they will feel it. This is also the gift of discerning of spirits in operation. You are making a demand on people to feel God's power.

Jesus said, "Hitherto have ye asked nothing in my name: ask, and ye shall receive, that your joy may be full." (John 16:24) James 4:2 says, "...ye have not, because ye ask not." The word "ask" in both of these passages is the Greek word "aiteo" which has a fuller meaning in the Greek of "to strictly demand what's due". There are many other verses in the New Testament that use this Greek word "aiteo". What we are doing is making a demand upon God's power to go into people's bodies in Jesus' name. Note, we are not demanding God Himself to do anything. What we are doing is demanding that circumstances and this natural world line up with God's Word. Jesus died on the cross so we can have authority in this world. A book that will really change your life along these lines is Brother Kenneth E. Hagin, Sr.'s book, *The Believer's Authority*.

Whenever I pray for people, I purposely initiate the gifts. God has already initiated giving them to me and you, so I initiate using them. It's just like when I leave my church building after church on Sundays. I purposely initiate driving my car. I have the keys and I turn the car on. In the same way, God has given us gifts and we need to initiate the gifts. We need to turn on the gifts in order to operate in them or use them. In the same way I initiate seeing an apple, I initiate a light going out of my hand and going into people's bodies and driving out demons and causing healing and the power of God to manifest. And it works!

We can initiate our imagination, our spiritual eyes, because knowledge has been introduced into our brain. In the latter example, supernatural knowledge

has been introduced into our brains and we need to act like we are the body of Christ. We are the fullness of Him and we fulfill the mind and purpose of God in this world. He "...hath put all things under his [Jesus'] feet, and gave him to be the head over all things to the church, Which is his body, the fulness of him that filleth all in all." (Ephesians 1:22-23)

"And God hath set some in the church, first apostles, secondarily prophets, thirdly teachers, after that miracles, then *gifts* of healings, helps, governments, diversities of tongues. Are all apostles? are all prophets? are all teachers? are all workers of miracles? Have all the *gifts* of healing? do all speak with tongues? do all interpret?" (1 Corinthians 12:28-30) Notice these passages start out by saying, "...God hath *set some* in the church...". The italicized word "set" here is the Greek word "tithēmi" which is also rendered as "appoint, ordain, establish". The italicized word "some", after that, is the Greek word "men" which is also rendered as "indeed, truly, certainly, surely". These verses are talking about offices. He has ordained the offices found in verses 28 through 30. It would be out of order or out of context to call any of the positions listed in 1 Corinthians 12:28-30 as gifts, as God has ordained these as offices. These passages are talking strictly about offices, not gifts.

The word "gifts", used above, is the Greek word "charisma" which is also rendered as "miraculous faculty". The word "faculty" in the Webster's Dictionary is rendered as "teacher, professor, instructor", which clearly references an office. The Greek word "charisma" is one of those words that can be its own oppo-

106

site. Just like the word "out" has its own opposite. The word "out" can mean "visible" or " invisible". For example: "Since the moon was out, people turned their lights out." The Greek word "charisma" can be used to refer to a spiritual, miraculous gift or it can also be used to reference an office, meaning a calling or vocation. The context of the verse or verses around the word determines which way it is to be used. In the case of 1 Corinthians 12:28-30, it is very clear that this passage is talking about offices and not gifts, so the positions listed in verses 28 and 30 should be referred to as offices.

The accurate translation, then, of 1 Corinthians 12:28-30 is: "And God hath ordained certainly in the church, first apostles, secondarily prophets, thirdly teachers, after that miracles, then *offices* of healing, helps, governments, diversities of tongues. Are all apostles? are all prophets? are all teachers? are all workers of miracles? Have all the *offices* of healing? do all speak with tongues? do all interpret?" And again, the answer to that is no.

As we study 1 Corinthians 12:28-30, you will notice, when talking about the offices, that it appears to the casual reader that not all nine offices are mentioned. The reason is that the office of an apostle includes the office of faith. The office of a prophet also includes the office of the word of wisdom and the office of the word of knowledge and the discerning of spirits. They come along with that office. So all the offices are mentioned. It is just done by simply mentioning certain offices that include more than one office in them.

All nine gifts of the Holy Spirit has an office that is similar. As I've mentioned before, there is a gift of prophecy and the office of prophecy (or the office of a prophet). They are similar, yet very different. A prophet prophesies all of the time, but a person with the gift of prophecy only does so on occasion. A prophet may say, "I see a spirit or I see something in the spirit world." They see in the spirit world. A person in the office of a prophet will say something at times about people, places, events or things of the past or present. And then there will be times a prophet will see or know something about the future in regards to a person, place, thing or event.

In closing, don't forget that there are diversities (varieties) of gifts but the same Spirit, (1 Corinthians 12:4), and that "...the manifestation of the Spirit is given to every man [everyone] to profit withal." (1 Corinthians 12:7)

1 Corinthians 14 exhorts us to: "...desire spiritual gifts..." (vs. 1) and "...forasmuch as ye are zealous of spiritual gifts, seek that ye may excel to the edifying of the church." (vs. 12)

Finally, "Let all things be done decently and in order. " (1 Corinthians 14:40)

ADDITIONAL RESOURCES BY MEL BOND

Releasing God's Anointing

How To See In The Spirit World

God's Last Days' People

Heaven Declares Christians' Greatest Problem

Understanding Your Worst Enemy

Why Jesus Appears To People Today

Neglecting Signs And Wonders Is Neglecting The Rapture

31 Reasons Every Believer Needs To Speak In Tongues

Mystery Of The Ages

Unimaginable Love

Ordination Of Imagination

If It's Not Good, It's Not God

Come Up Higher (Donna Bond, CD)